PAINTING BEAUTIFUL
Watercolors from
Photographs

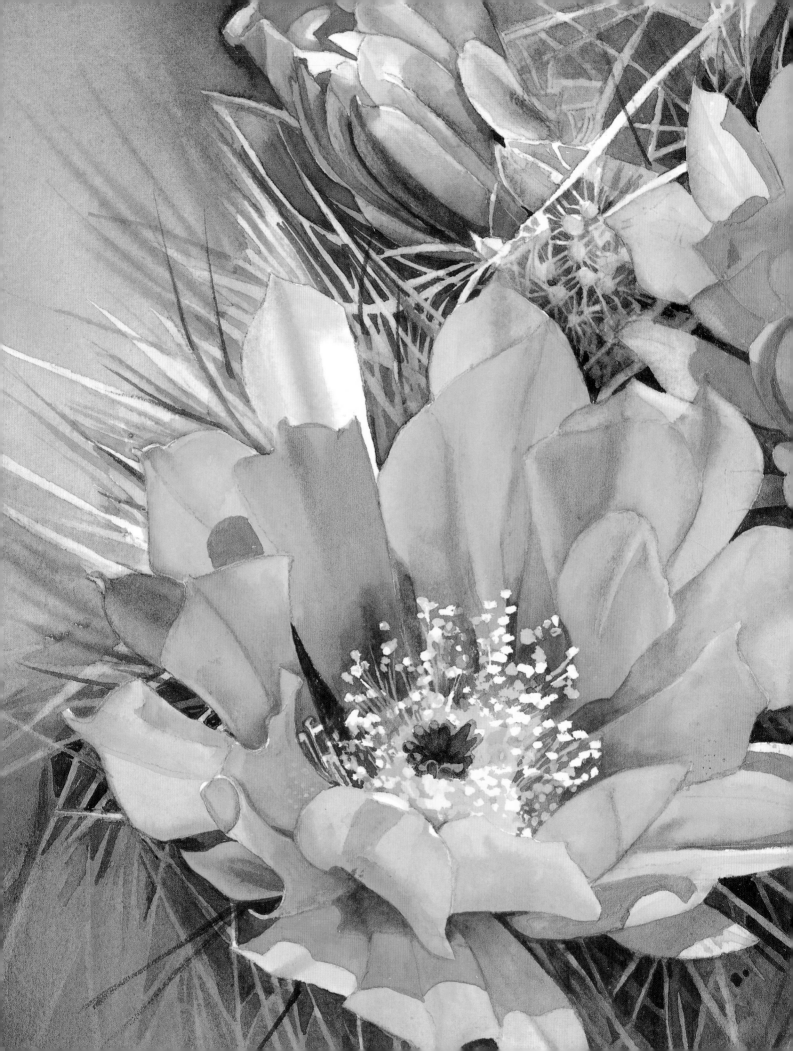

PAINTING
BEAUTIFUL
Watercolors
from
Photographs

Jan Kunz

NORTH LIGHT BOOKS
Cincinnati, Ohio

Dedication
To Bill

Acknowledgments
I'm indebted to the friends in the arts who have enriched my life: the many artists who have shared their love of watercolor with me. Thanks to Greg for being there, and to Helen Kropp, Monte Preston, Lynn Powers and Bill Kunz, who have made traveling fun, despite the pressures of air travel and long road trips. Thanks to Irma Eubanks for the steadfast loyalty and friendship she extends to every artist. Special thanks to all the people at North Light: Jennifer Long whose expert guidance has helped iron out the rough places, Pam Seyring for getting things started, and to my friend Rachel Wolf, for whom I have great admiration and respect.

About the Author
Jan Kunz is a resident of Newport, Oregon. She spent her early years working as a commercial artist and finally as art director of a large advertising concern in southern California. Since she and her husband, Bill, moved to Oregon in 1980, she has enjoyed a new career painting in watercolor. She is a signature member of "The Western Academy of Women Artists," and for the last seventeen years, has exhibited at the prestigious Peppertree Fine Arts Show in California.

 Jan teaches watercolor in workshops across the country, and is the author of three other North Light Books including *Painting Watercolor Portraits That Glow*, *Painting Watercolor Florals That Glow* and *Watercolor Techniques*.

Painting Beautiful Watercolors From Photographs. Copyright © 1998 by Jan Kunz. Manufactured in China. All rights reserved. No part of this book may be reproduced in any form or by any electronic or mechanical means including information storage and retrieval systems without permission in writing from the publisher, except by a reviewer, who may quote brief passages in a review. Published by North Light Books, an imprint of F&W Publications, Inc., 1507 Dana Avenue, Cincinnati, Ohio 45207. (800) 289-0963. First edition.

Other fine North Light Books are available from your local bookstore, art supply store or direct from the publisher.

02 01 00 99 98 5 4 3 2 1

Library of Congress Cataloging-in-Publication Data

Kunz, Jan.
 Painting beautiful watercolors from photographs / by Jan Kunz.—1st ed.
 p. cm.
 Includes index.
 ISBN 0-89134-791-7 (alk. paper)
 1. Watercolor painting—Technique. 2. Painting from photographs. I. Title.
ND2422.K86 1998
751.42'2—dc21
 97-27742
 CIP

Edited by Jennifer Long
Production edited by Jennifer Lepore
Cover and interior designed by Angela Lennert Wilcox

Mother's Treasures, 30" × 22" (76.2cm × 55.9cm)

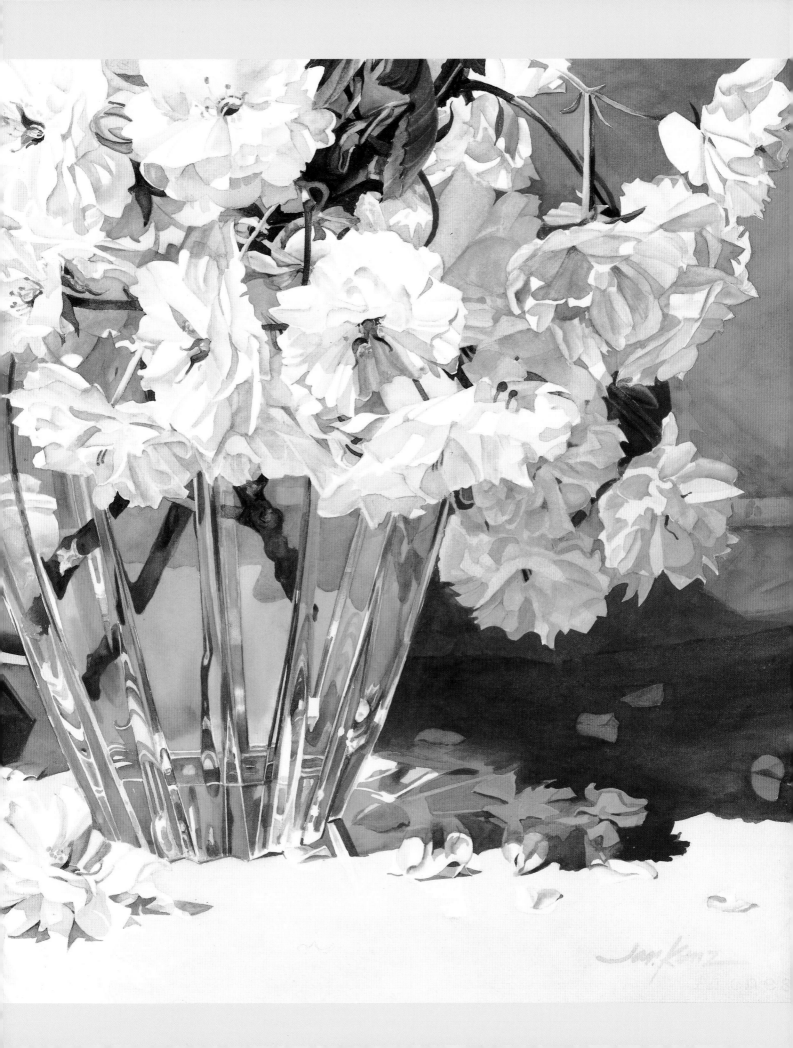

TABLE OF CONTENTS

▼ *Indian Pots, 30" × 22" (76.2cm × 55.9cm)*

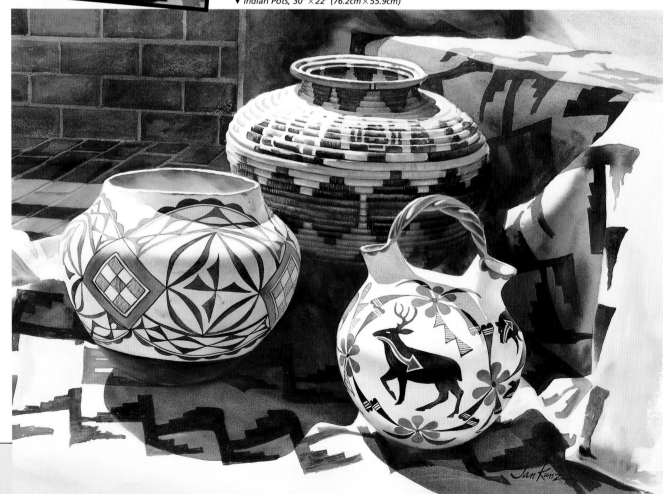

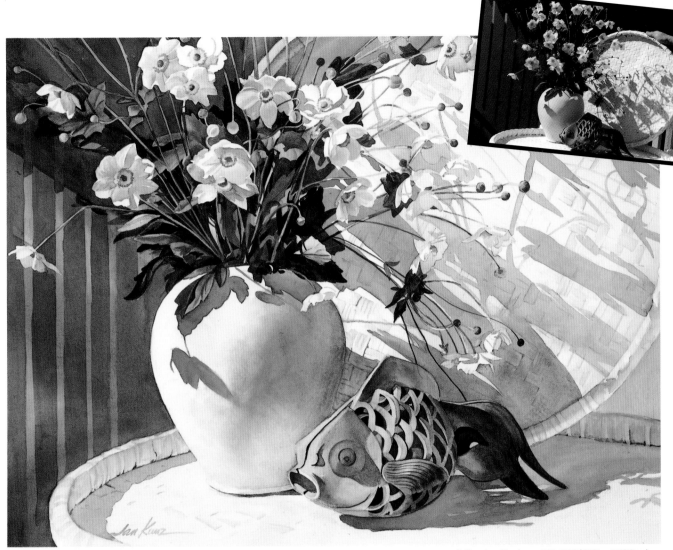

▲ *Dancing Shadows, 25" × 19" (63.5cm × 48.3cm)*

Why Work From Photographs?

Occasionally, some plein air painters—those who paint scenes outdoors directly from observation—adopt a superior attitude over those of us who admit to working from photographs in our studios. After all, they have faced ants crawling in their socks, sand in their palettes and wind blowing their paper away. (When painting outside one cold day, my teacher complained he had so many clothes on that his arms couldn't bend to reach the paper.)

However, the additional suffering endured by plein air painters does not insure their paintings will be better. In fact, Robert Henri (American, 1865–1929), author of *The Art Spirit*, tells us that a successful painting is a remarkable feat of organization. It is the result of skill, planning and concentration. He doesn't mention anything about the source of inspiration.

The fact is, I don't know one professional painter who hasn't made use of photographs at one time or another. Photographs are convenient—they're available when you want to paint and you never have to worry about the weather. If your photo files are full of paintable subjects, every day is a beautiful day in the studio. Your paint supplies are at hand, and you can listen to music as you work.

There are lots of reasons to paint from photographs, even on sunny days. Shadows don't move, children don't wiggle, reflections stay in one place and flowers don't wilt. The fact that you're not racing the sun gives you time to carefully plan your painting, rearrange or eliminate pictorial elements, decide on color combinations, make value studies and more.

There are times when you see something you want to paint, but circumstances make it impossible; that's when your camera can record the scene. I also carry a sketchbook in my camera case so I can make sketches or jot down anything that will bring back a more vivid memory of the scene.

Photos are a must for those whose only time to paint is after the children are in bed. (There were years when my family thought the best things to come from the kitchen were a few paintings; you bet I painted from photos!) In fact, I always use photos when teaching my floral and still-life classes because it's often impractical to provide a setup where everyone has equal access to the subject. Even though every student is working from a copy of the same photo, their resulting paintings are unique.

The purpose of this book is to help you recognize the photos in your collection that will make good subjects, and how problem photos can sometimes be transformed into exciting paintings.

Pullin' Power, 30" × 22" (76.2cm × 55.9cm)

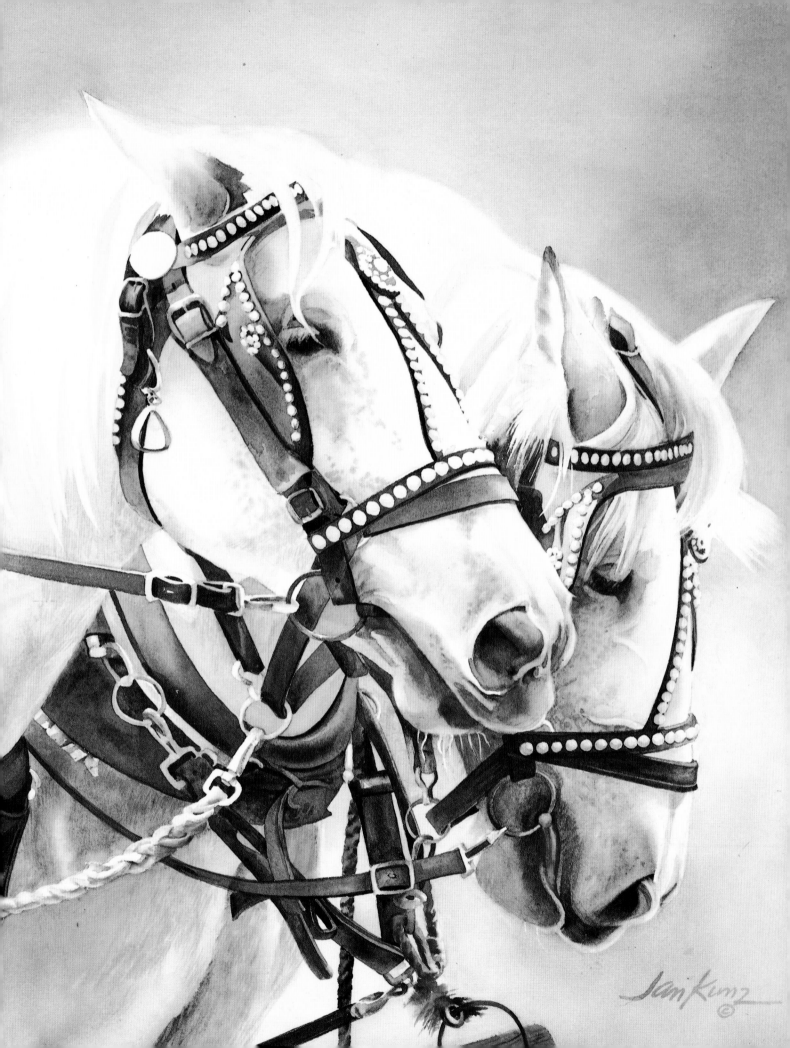

1
Shooting and Choosing Photographs

Even though you may not have much experience with photography, I believe the best photos are those you've taken yourself because the things you photograph interest you, and that's a good beginning for any painting. One acceptable photo out of a roll of thirty-six isn't bad. Though your photo may not be perfect, it should ideally be in focus, with well-defined detail in both sunlit and shadow areas.

Even when photos are taken with a painting in mind, most of them need some changes before they make good compositions. The camera works only with shapes, value, color, lines and edges. Unlike the camera, you aren't limited to what you see. When you paint from a photo, you can and should be creative and make changes that suit your purpose.

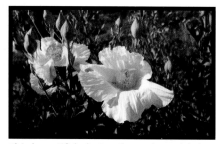

This beautiful photo of poppies, with its good shadow shapes and clear detail, invites painting. I decided to reduce the space around the flowers and bring them closer together in order to make them even more important.

Crepe Paper Poppies, 8" × 11" (20.3cm × 27.9cm)

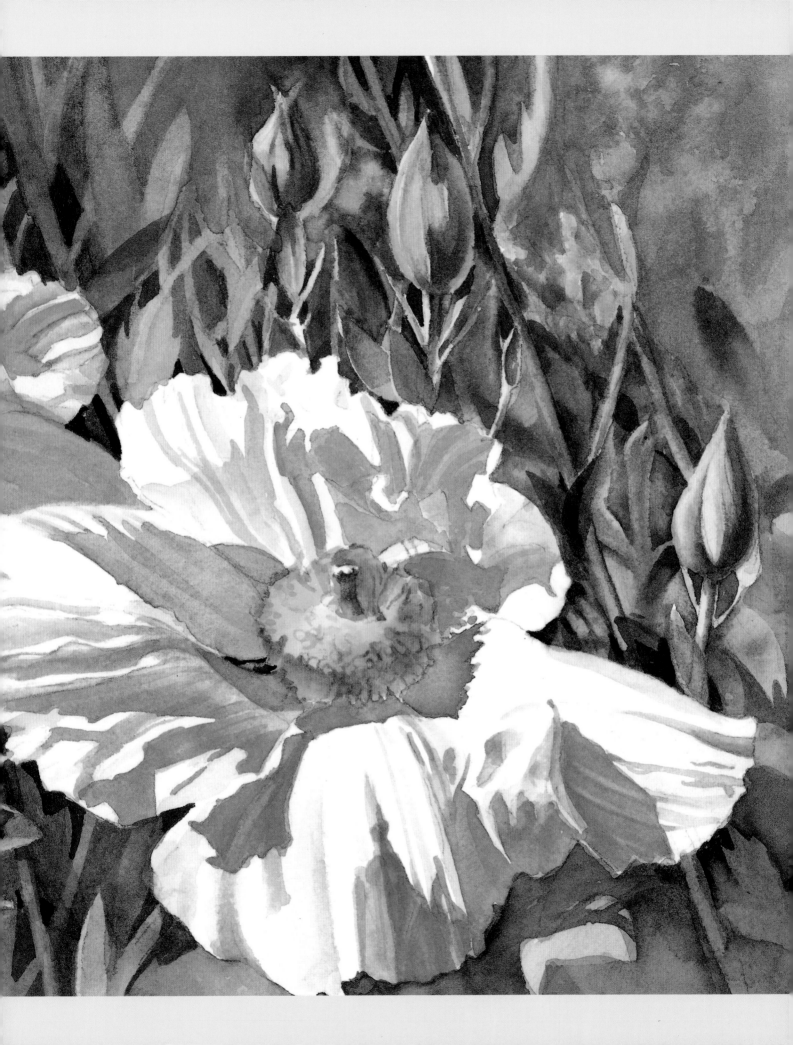

Photo Tips for Painters

Tip: Get Good Camera Equipment

If you're careful with composition and lighting, a good camera will do the rest. I have two cameras: a Minolta Maxxum 5000i with a 100-300mm zoom lens and a Pentax K1000 with a standard 50mm lens. I never use a flash because it flattens the values.

A telephoto lens is a useful addition to capture good detail on close-up shots, especially when you're taking photographs of flowers. Objects photographed too close to the camera often appear enlarged or out of scale; vertical walls can take on a strange angle, and sometimes there are subtle distortions in perspective. These problems are easily avoided by using a telephoto lens on your camera.

Tip: Keep a Sketchbook Handy

Keep a sketchbook in your camera case and draw any detail you think your camera might miss. Take notes of what attracted you to the scene—the weather or even the aroma of a place can influence your perception. You'll be glad to have as much information as possible when you begin to paint.

Tip: Keep Your Painting in Mind When Taking a Photo

When taking pictures to use in paintings, think like a painter, composing the picture carefully and gathering any related information you might need about your subject. For instance, when you photograph flowers, you might want to photograph individual stems, leaves and buds so you have that information for your painting. If you're shooting a dwelling, you may need detail shots of doors and stairways.

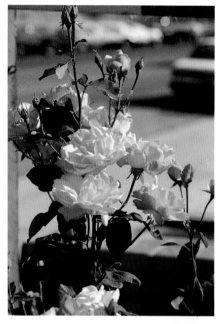

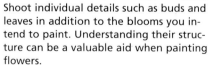
Shoot individual details such as buds and leaves in addition to the blooms you intend to paint. Understanding their structure can be a valuable aid when painting flowers.

Tip: Choose the Film That Works Best for You

Slides and print film work equally well, so choose the one that works best for you. The real differences lie in how you store them for reference and how you enlarge the images. I prefer prints to slides simply because they're more convenient to view and store.

Tip: Store Your Photographic Materials So You Can Find Them

The method I like best is to stamp the back of photographic prints with the date I receive them and then stamp the envelope containing the negatives with the same date. The prints are stored according to subject and the negatives according to date. Consider buying a date stamp to save time and frustration.

Slides are stored in small boxes labeled according to subject; these boxes are stored in larger boxes containing similar subjects. It doesn't take long to locate a particular slide. A nice addition to any studio is a small lightbox to use for viewing slides.

Tip: Schedule a Photo Shoot

Many professional painters schedule a photo shoot to gather material for their paintings. They make arrangements to spend a day, or even several days, gathering photographs for several weeks of paintings. Devoting a day to gathering painting reference material, whether in a garden, open-air market or your backyard, may save time and result in better pictures. I find it helpful and fun to invite a painting buddy along to lend a hand in locating paintable material and setting up still-life props.

Tip: Plan Ahead When Using a Model

If you paint people, take a lesson from artist Norman Rockwell, whose scenes were first imagined. Before a shoot, plan how you might pose your model, arrange for costumes, etc. Make sketches of how you envision the final picture and be prepared to take full advantage of your time with a model. Ask your model to wear middle-value or light clothing because very dark colors can appear flat in a photo.

Scrap File

A scrap file is a valuable resource for any painter. Collect pictures of things that interest you and that you might need for reference in a painting somewhere down the line—anything from pictures of period clothing to kitchen utensils. But don't make the mistake of just tossing your pictures in a box. You can end up spending hours trying to find the one you need. Organize your photos. As you'll see, I refer to my scrap file many times while doing the demonstrations in this book.

Taking Photographs of Flowers

I like to photograph flowers in the morning when there's a chance of dew clinging to the petals. Even without dew, you get the best pictures in the morning or afternoon when there are shadows to help define shapes. Flowers from a florist usually appear too perfect and fragile for my taste; I prefer to photograph flowers from a garden or nursery. As I mentioned earlier, it's good to photograph stems and leaves as well as the back of any flower. You won't know when you'll wish you had that information.

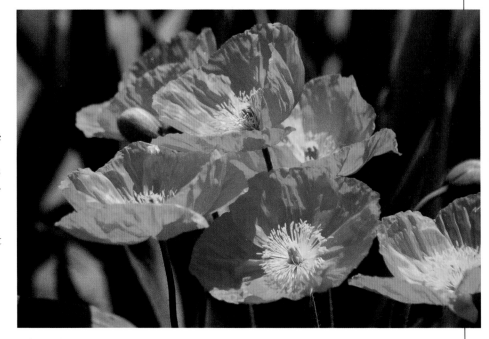

The "Never Fail Nail"

There should be only one source of light in a painting. Shadows in your picture become confusing if light comes from more than one direction. This can occur if you're painting from more than one photo; perhaps you're taking photos in a garden where blooms are widely scattered and you need to combine several photos to complete a painting. That's when I use my "never fail nail."

Push a nail up from the underside of a stiff card so it pokes up vertically through the center. Draw an arrow on the card in the direction you point the camera and mark a line along the shadow cast by the nail. Use the card for all the photographs you plan to combine, making sure the shadow of the nail falls along the line you made. Now you can be sure the light comes from the same direction.

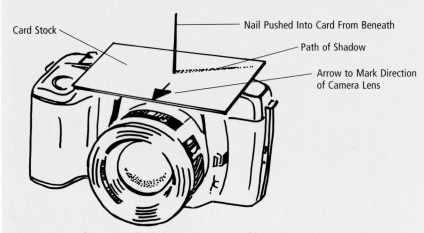

The shadow of a nail pushed through a piece of heavy paper (or a business card) will mark the direction of the light; the arrow points in the same direction as the camera lens.

Taking Photographs of People

Posing children can be risky; you may get anything from full cooperation to total refusal. For natural expressions, get children engaged in an interesting activity. If your models are having fun, they'll be less self-conscious, and perhaps even forget you're there. Starting with a fully loaded camera, take several photos in rapid succession when they don't expect it. One paintable picture in a roll is a good average.

Adults won't forget you're there with the camera, but if you move quickly, engage them in conversation and shoot when they least expect it, you stand a good chance of getting a photograph everyone will like. If you plan a formal sitting for a portrait, make your model comfortable, then take several reference photographs.

I try to photograph children outdoors, but if you take pictures inside, place your models near a window to get a good value pattern.

Beware of cute photos: A silly expression, grimace or awkward gesture can look like a disease in the hands of most painters. Paintings made from photos of children wearing braces or missing front teeth can cause embarrassment, and I think they should be avoided.

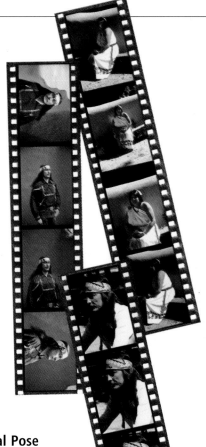

Capturing a Natural Pose
By taking photos in rapid succession you can sometimes catch an unguarded pose.

Taking Photographs of Animals

If you've ever tried to photograph a domestic animal, you may have discovered the biggest problem is keeping them back from the camera; their natural curiosity makes them want to explore the strange object in your hand. If you're too close to an animal when you snap the photo, the head can appear much too large for the body. I know this sounds obvious, but I have seen paintings made from photographs where the artist has copied this distortion. It's easier than you think to make this kind of mistake. Avoid this problem by photographing animals from a distance with a telephoto lens.

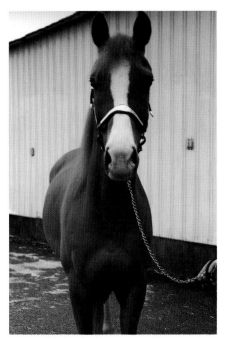 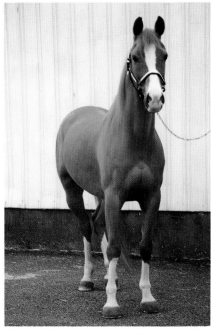

Notice how much larger the horse's head appears in the photo at left when compared with the right photo, which was taken with a telephoto lens at considerable distance. Distortions can occur when photos are taken at short range.

Building a Still-Life "Stage"

For still-life pictures, consider building a "stage." This simple box gives you the opportunity to become a stage manager and arrange a still life so light objects appear against dark surfaces, or dark objects appear against light backdrops. Of the three aspects of color—hue, value and intensity—value is by far the most important. Your job is to arrange an interesting pattern of dark and light values. You're working in a confined space, so you have good control over every aspect of your still life. Experiment with dramatic lighting effects, placement and color distribution.

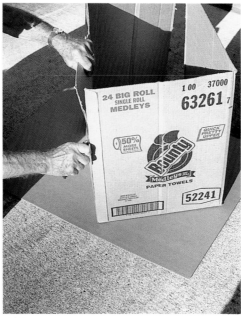

1. Cut
Use a sharp knife to cut along opposite corners of a cardboard carton.

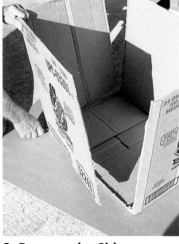

2. Remove the Sides
Cut along the bottom edge to remove two adjacent sides of the box, leaving the bottom and the other two adjacent sides.

3. Position the Lighting
The remaining two sides and bottom of the carton become a stage for your arrangement. Place the box so light strikes one side of the background and the other is in shadow.

4. Set the Stage
Now you can arrange objects so their shadows are seen against the sunny side of the background and the sunlit side of the objects stand out against the dark background. This principle of light against dark and dark against light makes each form easily recognizable. Achieve other lighting effects by putting a cover across the stage. Select props and decorate to your liking. Once everything's in place, photograph the arrangement. With your reference photo, your arrangement lasts as long as you need it.

Lighting

Light and shadows give form to objects in your paintings. Keep the lighting simple; avoid confusing cast shadows and try to arrange your picture so every object has a light and shadow side. Your subject takes on a whole new appearance depending on the direction of light. Photos taken in the morning or afternoon seem to be best. Midday shadows are usually flat and uninteresting; shadows on objects photographed late in the day become almost opaque. When you select photos, look for clearly visible shadow shapes as well as plenty of detail in both the sunlit and shadow areas.

Lighting from one side usually produces better shadow shapes than light coming from overhead or directly in front of the subject. For this reason, portraits photographed in a professional studio make poor subjects for painting; not only is the photograph not your own, but the photographer usually tries to eliminate any shadows across the face of his model. Because of the lack of shadows, I also recommend against painting flowers from the pictures in seed catalogs.

Backlighting produces dramatic effects. Translucent surfaces like flowers, crystal vases, etc., take on new beauty when lit from behind.

Simple light and shadow shapes give form to the objects in your pictures.

Confusing cast shadows can diminish the basic form and should be avoided.

Painting the Illusion of Sunlight

The trick to painting sunlit objects is simple: The shadow side must be 40 percent darker than the sunlit side. Scientists tell us the average human eye distinguishes ten or eleven distinct values ranging from light to dark. By constructing a chart with ten shades of gray evenly divided from white to black—using off-white watercolor paper as value one and black as ten—you need only count up or down four values to arrive at a 40 percent difference. A value scale is a valuable tool you can make yourself; I use my value scale to compare values in my painting with those in the photo. The more you know about color and value before you paint, the easier it is to see color and make choices during the painting process.

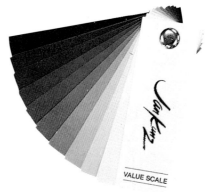

VALUE SCALE

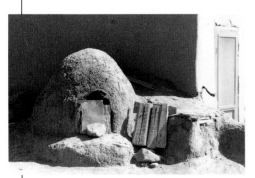

The top and the front of this ancient oven at the Taos Pueblo in New Mexico are cooler in color temperature than the side in direct sunlight. You can also see reflected light on the shadow side of the oven.

Points to Remember When Painting on a Sunny Day

1 The shadow side of an object is about 40 percent darker than the sunlit side.

2 Surfaces facing the sun are usually warmer in color temperature than those turned from the light.

3 The shadow color on a white object is usually a neutralized blue-gray of middle value.

4 Cast shadows are somewhat darker than the shadow side of an object and usually do not contain reflected light.

5 Areas not affected by sunlight, such as holes and crevices, are usually warm in color temperature.

6 The shadow side of an object contains reflected light, which adds interest and color. Reflected light is light thrown back on an object by another object; for example, if you paint a white pitcher placed on a red cloth, some red will be reflected in the pitcher.

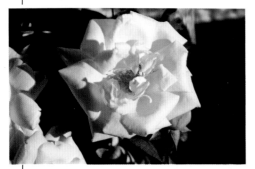

You can see a variety of shapes within the rose above, but what do they tell you? Start with what you know about the color of objects in sunlight. Sunlit surfaces are usually warmer in color temperature than ones turned from the light. The shadow color on a white object is usually a neutralized blue-gray of about middle value. Reflected light adds interest and color to the shadow side. Finally, notice places where the sunlight has penetrated a petal and has formed light places in the cast shadows. By understanding what you see, you can make a better painting.

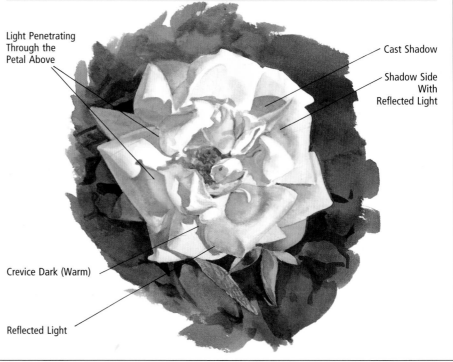

Light Penetrating Through the Petal Above

Cast Shadow

Shadow Side With Reflected Light

Crevice Dark (Warm)

Reflected Light

Choosing a Composition

You are the artist. Your good common sense is your best guide in selecting photos and deciding how much of the photo to include in your painting, so trust your own creative ability. Select the photo you really want to paint—you'll do best if you're excited about your subject. It's been said there is no creation without passion, and I believe that's especially true of painting. I've seen wonderful paintings from the most unlikely photos. Show your viewers something new, or present an old subject in a new way. From dolls to diesel engines, wonderful material is almost everywhere. Be imaginative.

No matter which photo you choose as a subject, your next concern must be the composition of your painting. Arrange the elements within the picture space to communicate your idea to the viewer. Think of elements as shapes rather than houses, flowers or other objects.

Good, unified composition requires that one shape, or a collection of similar smaller shapes, dominates the picture. Contrasting shapes add interest but must be subordinate to the central form. Beware of photos where objects are so close together it becomes difficult to distinguish between them, or where they're positioned in such a way as to obscure their shapes.

When you paint from nature, it's usually necessary to simplify shapes. The same thing happens when you paint from a photograph. Of course, your field of vision is much smaller when you're painting from a photograph, but on the good side, you aren't distracted by things around you. Intrigue viewers with what you have to show them, but be careful not to show too much. By copying any photo in exact detail, you risk confusing or boring your viewers.

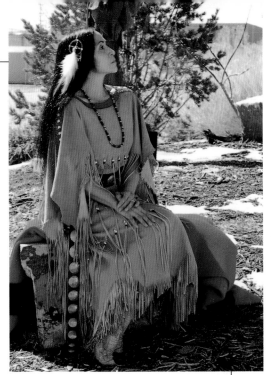

Stage Photos With a Painting in Mind

Staged poses should be carefully composed to keep changes minimal. This photo of O-Si-Ce-Ca-Win, a Ute woman from Colorado, was posed with the express purpose of using it for a painting. The backlighting reduces shadows on her face and figure, but good value contrasts remain. She's well placed in the picture, though I'd add space at her feet. Costume detail is clearly visible, and background buildings could be made to resemble cliffs. Notice how blues are repeated in the costume, background and shadowed leaves at her feet; the red of the blanket could be repeated in her headdress. Study even the best photos carefully; just because a photo works doesn't mean you can stop thinking!

Photos of interesting and unusual objects often make good paintings.

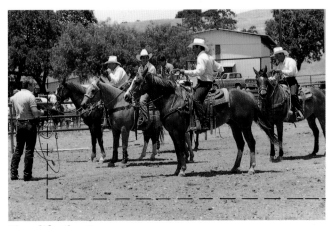

Simplify the Scene

With only minor revisions, this group of riders can become the basis for a painting. I think the figure on the left, as well as the truck in the background, should be removed to simplify the scene, and the riders can be brought further into the foreground by shortening the picture area.

Too Busy
Busy pictures can confuse your viewer. This photo needs simplification before it will make a good painting subject.

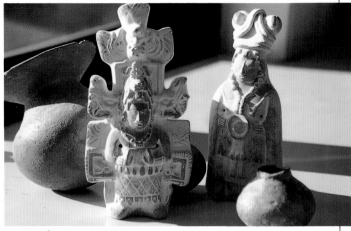

A Good Composition
Vertical shapes dominate this composition. The dominant vertical shape at left is reinforced by the other vertical figure in shadow, while pots and diagonals provide interesting contrast, or conflict, but don't overwhelm the dominant theme.

A Poor Composition
The pictorial elements in this photograph are of equal importance, therefore the composition lacks the dominant theme necessary for a good composition.

No Dominant Form
Flowers seldom arrange themselves into paintable groups. For example, there is no dominant form in this photo of flowers scattered about the picture area.

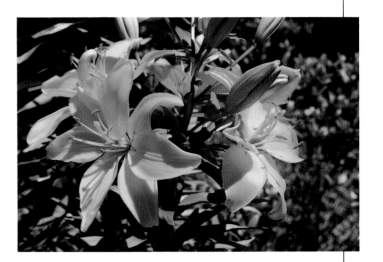

Shadow Shapes Are Important

Compare these two photos to see how important shadow shapes are. There is plenty of detail in both, but the shadow shapes in the picture at right add more interest, as well as help define the shapes of the flowers.

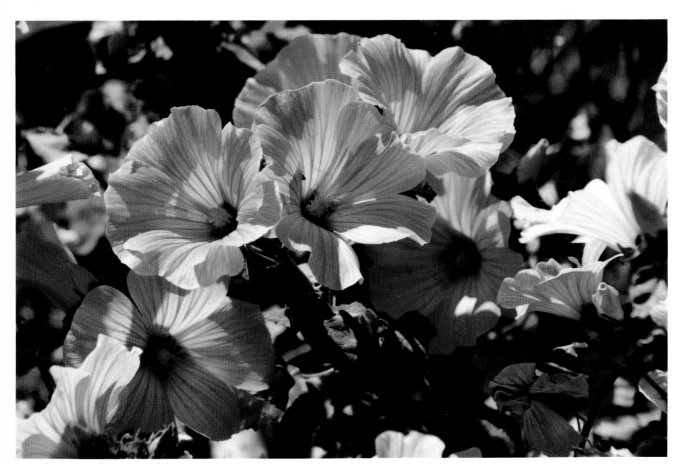

Another Good Composition

This photograph of beautiful flowers needs no changes to make a good composition, because several blossoms form a dominant shape. Unless you plan to paint a large single blossom or are lucky enough to find a photo like this one, you may need several photos to complete your composition.

Finding Many Compositions in One Photo

Several compositions can often be found in one photo by isolating different areas using mini-mat corners, made by cutting small **L** shapes out of stiff paper. By moving these corners around, you can find new pictures or wonderful abstract designs. This bouquet of roses provides opportunities for many paintings.

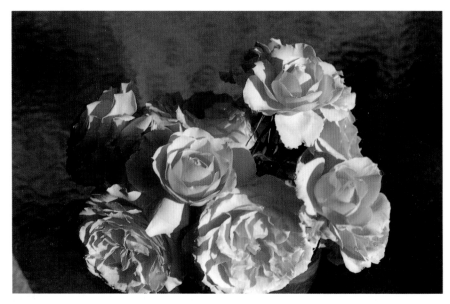

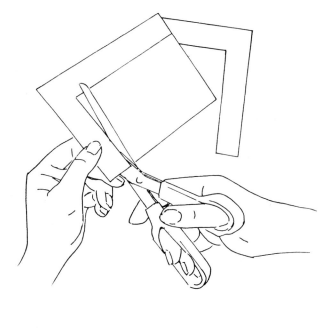

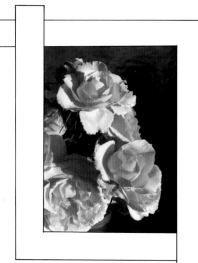

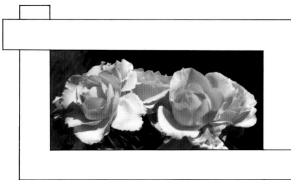

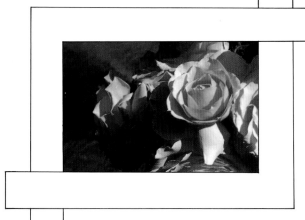

Making a Stop-and-Think Sketch

A completed painting should look effortless, but like so many things, reality is a different matter. Well-conceived, spontaneous paintings are usually the result of careful study and planning. Complete most of your planning before you transfer a composition to watercolor paper, because afterwards you're somewhat committed to the lines on your paper.

Even if you intend to copy your photo exactly, you may save yourself problems by making a quick "stop-and-think" sketch first. Put a piece of mat acetate or tracing paper over the photo, then copy the value pattern. I use vertical strokes on these sketches in order to see *shapes* rather than *things*. You risk including something you may later wish wasn't there without some kind of a check. It only takes a minute, and I promise it's a minute well spent.

However you arrive at the final drawing on your watercolor paper, it must represent the finest composition you're capable of. No fancy brushwork or detail can save a poor design. It's the end result that counts.

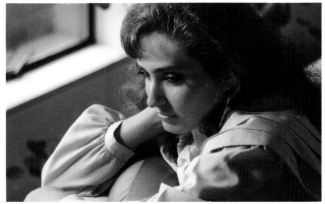

By reproducing the value pattern in your photo you can locate areas of equal value and spot any problem areas.

This window frame cuts out a portion of the picture area and detracts from the face.

Corrections made at this stage can increase your chances for a successful painting.

Deciding Which Lines to Transfer

Some people outline only main shapes when transferring photos to watercolor paper, while others make more detailed drawings. Copy any lines or shapes meaningful to you. It won't take long before you know just which lines you need. The overall shapes are important, but you must also locate subtle changes in color temperature as well as the location of cast shadows and shadow sides. Accurately trace every line you think you might need. It's easier to move or omit a part of your drawing than to add to it later on.

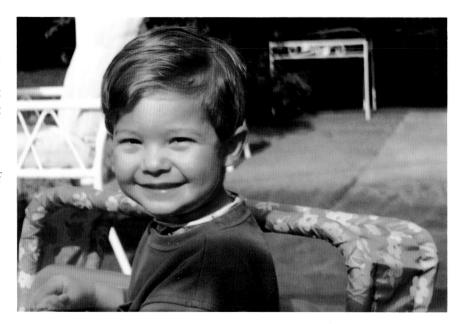

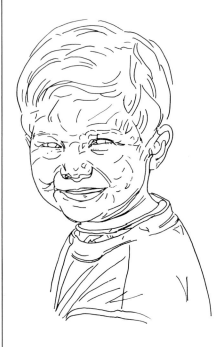

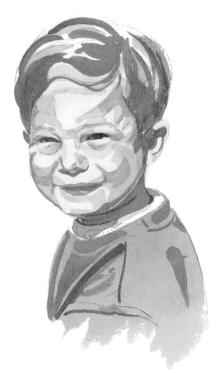

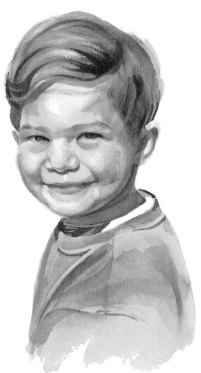

Compare the photo of Ian above with this drawing; in addition to copying the general outline of his face, I have also traced the shapes created by the cast shadows and the cooler areas that are turned from the light. Every line in this drawing is there to remind me of a particular shape.

In this sketch I've painted the various shapes outlined in the pencil drawing, using the photograph as a guide for color and value. The difference between this sketch and the one on the right is only in the quality of the edges. Once you've painted the right shape and value, it only remains to decide on whether a soft or hard edge is required to complete the illusion.

Transferring a Photo to Watercolor Paper

There are many ways to transfer a drawing, and you may already have a favorite method of your own. Be open to discovering new ways that suit you better; don't let prejudices influence your choice.

Freehand Drawing

Drawing a picture freehand directly from photo to watercolor paper is a straightforward and popular method of transferring a picture. Yet the temptation to paint *things* rather than plan a whole picture with *shapes* can be overwhelming. It took me years to appreciate the importance of a preliminary sketch to work out a value pattern and the placement of pictorial elements. Without some kind of a guide, drawing errors are likely and the paper can suffer from too much erasing and smudging.

Direct Painting

I like to call this the Evel Knievel transfer method because it's certainly not without risk. The artist uses the photo for inspiration only and paints directly onto the watercolor paper with no preliminary drawing. The peonies on page 29 are an example of this method—they were painted directly onto a dampened surface with no previous drawing.

This approach works well when painting large masses such as big skies, blocks of trees and simple landscapes. I often use this method for background foliage, underpainting or developing secondary shapes. Tree roots and rock formations often need little drawing; abstract designs can also be created using this method.

My Favorite Transfer Method

Here's the best transfer method I've found. Make a full-size drawing on tracing paper before transferring a composition to watercolor paper. This gives you the chance to study the composition and identify problems. Are shapes simple and easy to understand? Are there too many shapes? Is there a dominant form? Where's the contrasting element? If you need to add or delete an element it becomes obvious in plenty of time to make changes. When the bugs are worked out, trace the final version onto watercolor paper with the graphite transfer sheet technique described at right. Want to paint the scene again? The drawing on tracing paper is at your disposal.

Making a Graphite Transfer Sheet

1. Cover the back of a piece of good-quality tracing paper with graphite, using the side of a soft pencil or graphite stick. Cover the paper well.

2. Dampen a tissue with lighter fluid and use a circular motion to rub the graphite surface until it is evenly coated. Brush lightly with a dry tissue to remove any loose graphite.

3. To use your transfer sheet, put it facedown on your watercolor paper and put the drawing you want to copy faceup over it. Be sure to tape the top of your drawing to the watercolor paper so it won't slip around. Trace over every line of the drawing. As it may be hard to tell if you've traced over a line or not, I recommend putting a clean piece of tracing paper on top of your drawing before transferring so you can immediately see which lines you have traced onto the watercolor paper. Your transfer sheet will last a long time and can be used again and again. To prevent tearing, put a piece of tape around the edge.

Making Proportional Enlargements

Enlarging a Rectangle

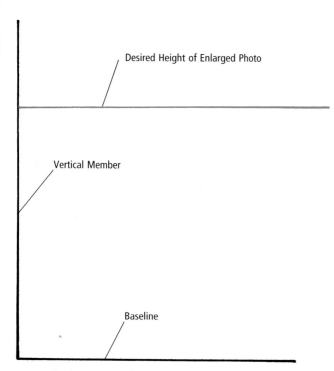

Desired Height of Enlarged Photo

Vertical Member

Baseline

1. Mark the Desired Height

Draw an **L** shape larger than the desired enlargement onto a piece of paper. Mark the height of the desired enlargement onto the vertical member, then draw a horizontal line parallel to the baseline through that point.

Time-Honored Tradition

Even Renaissance artists used drawing aids; rope grids strung on wooden frames were placed in front of models to act as drawing guides. Today, much the same method makes it an easy matter to draw accurate enlargements of original photos.

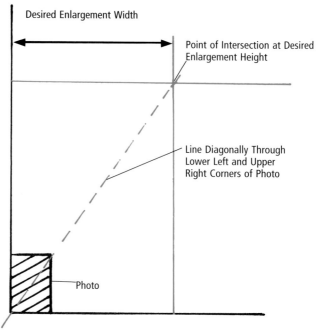

Desired Enlargement Width

Point of Intersection at Desired Enlargement Height

Line Diagonally Through Lower Left and Upper Right Corners of Photo

Photo

2. Find the New Width

Place the photo in the corner of the **L**. Extend a line from the lower left corner of the photo diagonally across to the upper right corner, extending it until the diagonal line reaches the horizontal line marking the new height. A vertical line from that point to the baseline completes a proportional enlargement of the original rectangle.

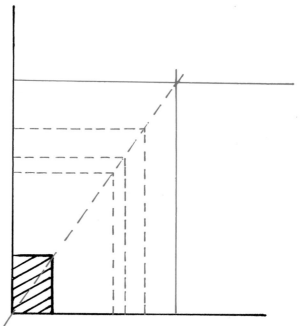

A proportional enlargement can be made from any place on the diagonal line, as indicated by the blue lines.

Using a Grid

1. Draw a Grid

Place tracing paper over the entire photo-graph, or just the part of it you're inter-ested in enlarging. Then draw a grid, as shown here.

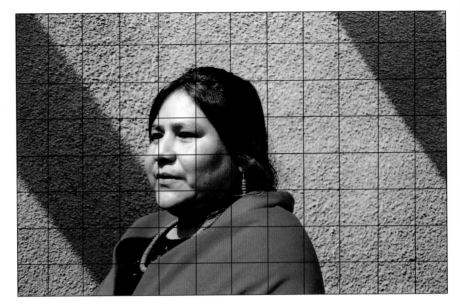

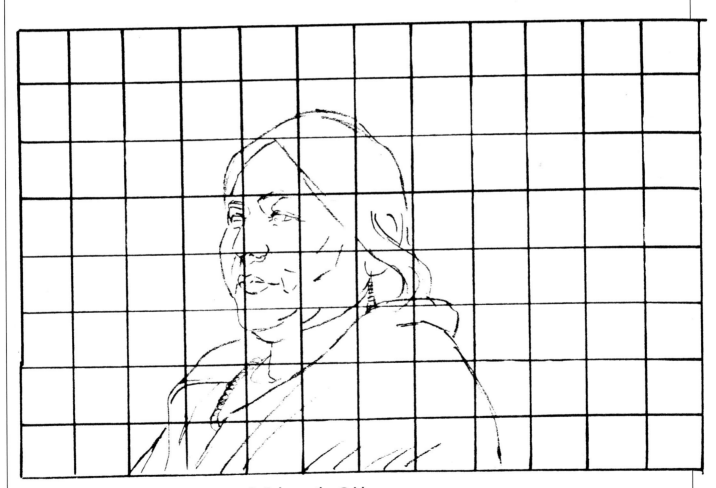

2. Enlarge the Grid

Draw a larger grid with the same number of squares on a piece of drawing paper proportional to the photo or area you're enlarging (using the instructions on the previous page). Copy simplified shapes from the photo into each square of the larger grid one at a time, either directly onto the drawing paper, or onto a piece of tracing paper placed over the enlarged grid so your drawing is grid free.

Using Mechanical Enlargement Methods

Slide Enlargements

Slides can be projected to almost any size directly onto watercolor paper. Outline the shapes to complete the drawing. To consult slides while painting, you must rely on a viewer that projects a small image, or a rear-screen projector. Some artists manage to place a screen between them and the projector, then view the picture from the back. A rear-screen projector is available that looks like a TV screen and works well in daylight. Less expensive is a laser or photo enlargement made from the slide. The color may not be as brilliant as the slide, but easy viewing may outweigh this problem.

Opaque Projectors

An opaque projector works much the same as a slide projector, but with this tool you can enlarge photographic prints, drawings or any other opaque material. The image can be projected onto a wall or tabletop depending on the type of projector; some opaque projectors also have the capacity to reduce an image or project three-dimensional objects. The range of enlargement may be somewhat limited, but I have found that to be a minor problem.

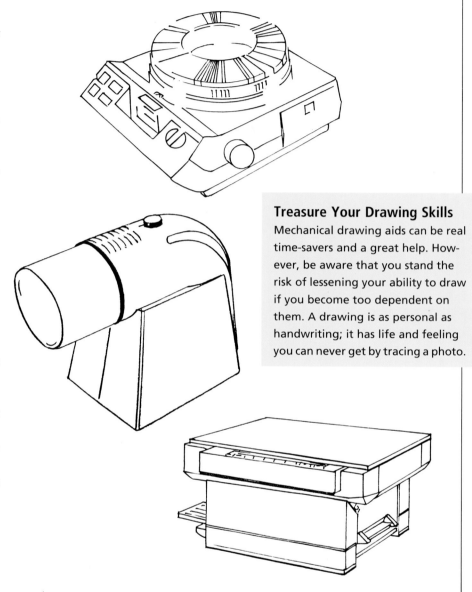

Treasure Your Drawing Skills
Mechanical drawing aids can be real time-savers and a great help. However, be aware that you stand the risk of lessening your ability to draw if you become too dependent on them. A drawing is as personal as handwriting; it has life and feeling you can never get by tracing a photo.

Photocopiers

Almost every painter I know has used a commercial photocopier to reproduce a drawing; it's the answer for painters who complain that the vigor of a sketch made in the field is lost when the sketch is enlarged for a painting. Photocopiers offer fast, quality prints in a wide range of sizes for very little money. Even many personal copiers have limited capabilities for enlarging or reducing drawings. A copier is one of those things you don't know you need until you have one.

Laser Enlargements

Tracing the image from a laser enlargement is a popular method for copying a photo onto watercolor paper. You can get full-color digital laser copies made from slide film or from prints in very little time. The image is printed on paper about the same weight as that of stationery, in a wide range of sizes depending on the available equipment. If you aren't sure where to get a laser copy, look in the yellow pages of your phone book under "copy." Some painters

trace directly from the laser enlargement onto their watercolor paper using a transfer sheet (see page 25). Others place the enlargement and the watercolor paper against a light table or window in order to see the image more clearly for tracing. The laser prints you may be able to get from the corner store are getting better, but refer to your original photograph for color and detail.

Points to Remember

1 Shoot photographs for both composition and information. Take your pictures with a painting in mind and get all the information you may need. Carry a sketchbook to make sketches and note how you feel about a scene.

2 The ideal photos for painting are those you take of things that interest you, with good focus, detail and shadows. But don't look for perfection; any photo can be the basis for a painting because you can make changes to suit your purposes. Select the photo you really want to paint. You're the artist.

3 Choose interesting subjects. Entertain your viewer by making an effort to show something new, or by presenting an old subject in a new way.

4 When taking photographs of people, you can get more natural poses by taking many photographs in rapid succession. Unposed photographs of children often make the best pictures.

5 Ask your model to wear middle-value or light clothing because dark clothing can appear flat in a photograph.

6 When taking photographs of animals, don't get too close when you snap the photo or else the animal's head can appear much too large for his body. To avoid this problem, photograph animals with a telephoto lens.

7 When taking photographs of flowers, photograph buds, stems and leaves, as well as the backs of blooms. Early morning or afternoon is the best time for photographing outdoors.

8 Lighting and values are important. Use a value scale for proper value relationships and to compare the values in your painting with those in the photo. Use light against dark, dark against light when arranging still lifes.

9 When combining photos, the light must come from the same direction. Multiple light sources create confusing shadows.

10 A good composition has one shape or a collection of smaller shapes dominating the picture. Isolate important parts of a photo with mini-mat corners.

11 Keep a scrap file arranged according to subject. It can be a valuable resource for any painter.

12 Plan your composition carefully with a preliminary stop-and-think sketch to work out a value pattern and the placement of pictorial elements before transferring it to watercolor paper. The final transfer must be the best you're capable of.

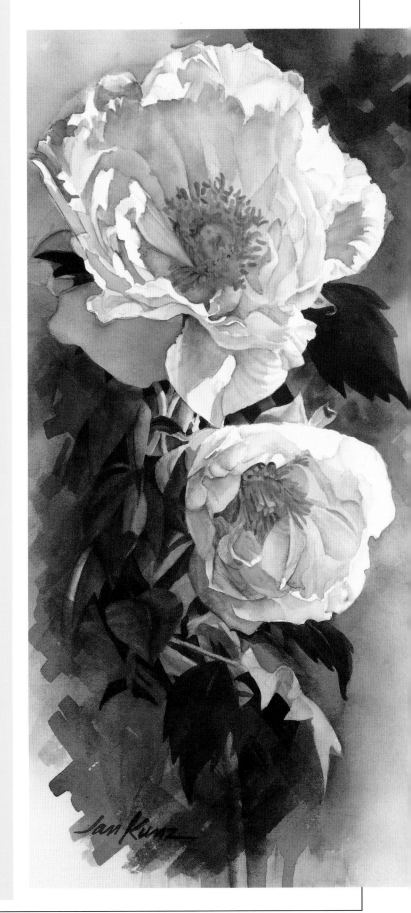

2
Painting From One Photo

In this section we will be working from reference photos that require few or no changes to make interesting paintings. I'm going to lead you through my way of painting these demonstrations step by step. Even if you are a beginning painter, I hope you'll paint them with me. It's helpful to use your value scale, or paint small swatches of color, to compare with your photo so you can make the right color and value choices. By putting a piece of mat acetate or tracing paper over your photo and tracing the patterns of dark and light, you can find places to connect darks and lose edges.

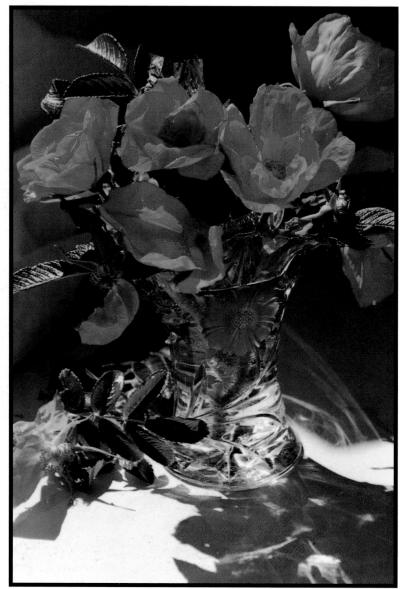

When you find a photo like this that you can paint just as it is, with no major changes, you have a head start on a successful painting.

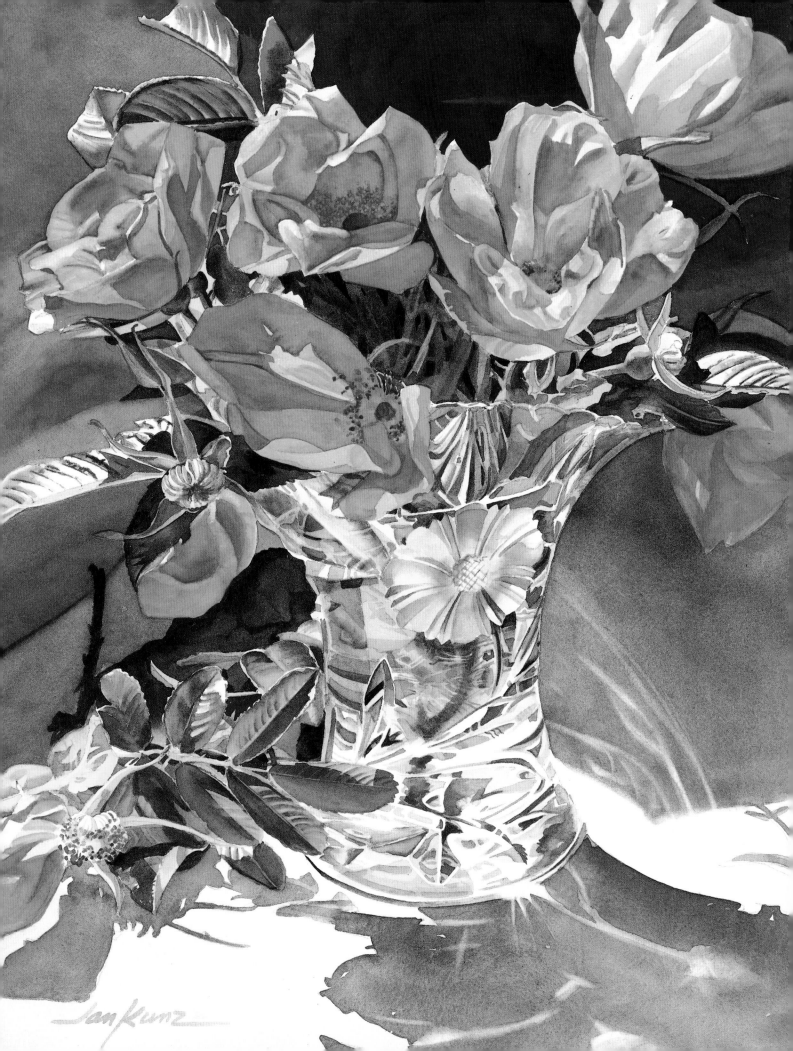

Crystal Vase

1. Studying the Photo

Even though I don't intend to make major changes to this photo, I omit the dark band across the bottom because the eye is drawn to that bold value contrast. Now look at the rest of the picture. We're looking at the shadow side of the objects in this photo. The sunlight penetrating the petals gives form to the roses, as well as adding brilliance to the crystal vase and cruet. The challenge is to capture the illusion of crystal. If you study the photo you'll see that both the cruet and vase are composed of many small shapes. Each shape may be a different size and color, yet they're small enough to control. By reproducing them one at a time, the resulting painting will give the illusion of crystal. The most difficult thing is having patience to see it through; it is nothing you can hurry. It is tedious, yet can be very rewarding. Many beginning painters are amazed with their success!

Start Where You're Comfortable

No rules tell you where to begin a painting; my teacher advised starting where each individual student felt comfortable. I usually work from light to dark values, but each painting is different. Start where you feel comfortable.

2. Enlarging the Drawing

I used an opaque projector to enlarge the photo, then traced around every visible shape. Obviously some shapes are missing, yet there's enough information in my drawing to make a convincing painting. Be as careful as you can; refer to the photo often so the lines make sense to you. You're drawing a collection of shapes, and the more careful you are with your drawing, the easier the painting will be. After tracing the drawing onto the watercolor paper, consider covering everything except where you're working. You'll be at this a long time, and by protecting the paper you preserve its surface.

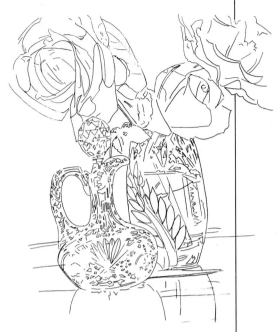

3. Starting the Cruet and Vase

Begin by painting each of the shapes on the cruet handle just as you see them; copy the color and value exactly, and be sure to make clean, hard edges. Notice the values are lighter on the body of the cruet than they are on the handle. I used Rose Madder Genuine, Cobalt Blue and Raw Sienna, as well as a variety of grays in the handle. To get a cool gray try mixing Cobalt Blue and Raw Umber. To warm this mixture just add Rose Madder Genuine. If you're not sure of a color, try it on a paper scrap first. Next move on to the neck. The shapes on the side of the cruet are not very distinguishable, but do the best you can by painting the ones you do see. The overall shapes of the cruet contribute to the illusion. You'll find it a relief to move over and paint the leaves on the crystal vase. Just paint what you see, being careful to maintain the hard edges. Try a very pale mixture of Raw Sienna and Winsor Green for the lightest values, then add darker values after the first layer has dried.

Raw Umber
+ Winsor Blue Mixture

Cobalt Blue

Rose Madder Genuine

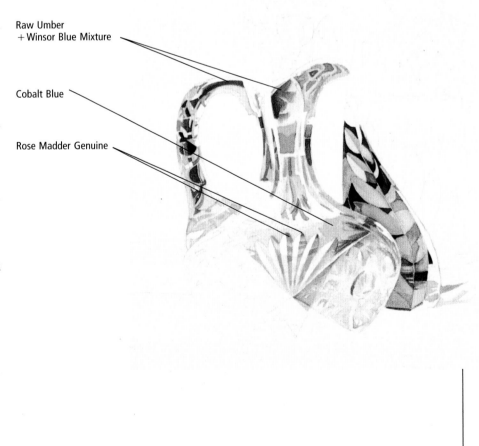

4. Painting the Body of the Vase

This goes much faster because the shapes are a bit larger, but it's important to work each shape. Pay attention to the color and value, as well as the quality of the edge. Try using various combinations of Winsor Blue, Winsor Green and Cobalt Blue. I see the stem of the flower as Burnt Sienna along the edge, and Burnt Umber mixed with Permanent Alizarin Crimson in the shadow area. View your work from a distance when you've finished this passage. You may find that working close for a long time can be hard on your eyes; you need a break now and then.

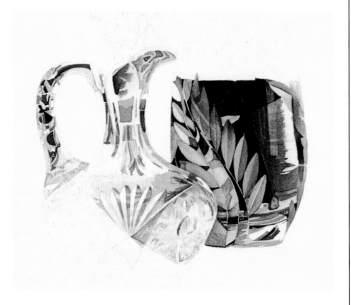

5. Continuing the Cruet and Left Rose

Painting the crystal stopper is pure fun; it's composed of a multitude of diagonal shapes, each one a different color. It's important to keep the colors clean and the edges hard. Look at the roses in the photo and try to repeat those colors in the stopper. The colors I see are Rose Madder Genuine, Permanent Rose, Permanent Alizarin Crimson, Raw Sienna, Burnt Sienna, Cobalt Blue and Winsor Blue. Yet color is a personal thing, so have confidence in your own color choices. Since you can see little detail in the left side of the cruet, just use a few confident brushstrokes to add some hard-edged shapes following the contour of the side. The dark background is a mixture of Permanent Alizarin Crimson and Burnt Umber with a few touches of Winsor Blue charged into the wet surface. Next paint the left rose. The light is coming from behind the flowers, so there's a considerable value difference between the translucent light on the outside petals and those near the center of the flower. Consider using a scrap of watercolor paper to make a trial match of the colors and values with the photo before you start. The light is also penetrating the leaf behind the rose, which makes the veins appear light in value. Coat the entire leaf using a yellow green made by mixing New Gamboge with a touch of Winsor Green.

Cover Finished Sections

Consider covering finished sections with tracing paper to protect them before you move on to new areas. After all that work, you don't want to risk dropping a glob of paint on a finished area.

6. Painting the Leaf and Right Rose
When the surface is dry, paint around the leaf veins with a darker green. Continue painting the other pink rose, being careful to keep the same value comparisons as in the photo.

7. Adding the Yellow-Orange Rose, Reflections and Shadows

The yellow-orange rose comes next. Use New Gamboge for sunlit areas. Yellow has a very short value range, so you must add various combinations of Permanent Alizarin Crimson, Cadmium Orange and Burnt Sienna to arrive at a sufficiently dark value. There are reflections as well as cast shadows on the surface of the table where the vase and cruet are resting. Paint the reflection directly under the cruet (the lightest value) first. Mix a light blue-gray and paint the whole shape. Let the color dry, then paint the reflection under the vase a slightly darker gray. After both reflections are thoroughly dry, paint the light blue tabletop, avoiding the reflection shapes. Let the entire surface dry once more and paint the cast shadows. Then glaze the entire foreground with a light wash of Cobalt Blue; this unifies the shapes and softens the edges of the reflections. The final touch is to lift out the highlights in the foreground with a stiff brush and clear water. Do this by dampening your brush and briskly rubbing the spots you want to lift, then blotting them dry with a tissue.

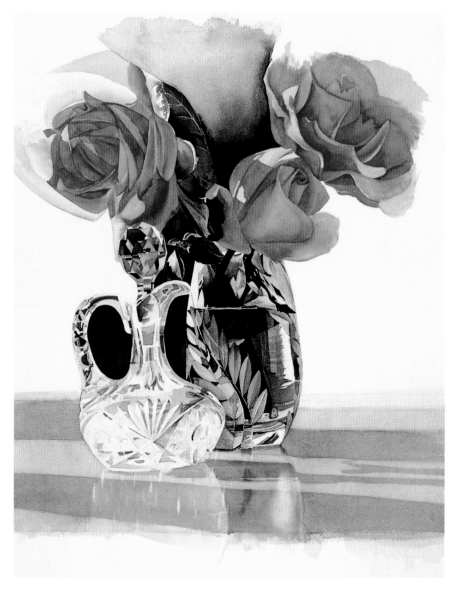

8. Adding Final Touches

Add the dark background and check your painting. Soften any hard edges on the rounded surfaces of the rose petals using a soft brush and clear water. After this experience, I hope you're ready to paint more crystal vases! They're an exciting subject. You're in for a lot of fun, as long as your patience and eyesight endure!

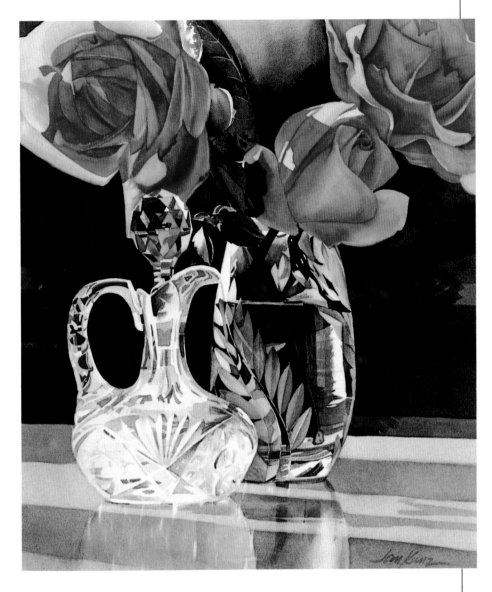

DEMONSTRATION 2

Kelly

1. Studying the Photo

Take a good look at the photo and analyze what you're seeing; you have a better chance for a successful painting if you learn everything you can about your subject before you start to paint. I selected this photo because Kelly's features are clearly visible, there's a good pattern of dark and light, and her smile is irresistible. If you squint your eyes you'll see that the value of her teeth is almost as dark as the shadows on her cheeks, and the whites of her eyes are darker still. There's a warm glow under her chin. There's reflected light on her neck and upper lip. We'll have to make sure the sunny spot on her left cheek doesn't become too important. This can be accomplished by reducing the value contrasts between it and the rest of her cheek. Also notice that each nostril is shaped like a comma, and her eyebrows are darker in the center than near her nose.

2. Making a Detailed Drawing

My drawing is very detailed; this helps me fix the position of shadow shapes and facial planes in my mind even though the lines may soon be obscured by the addition of color.

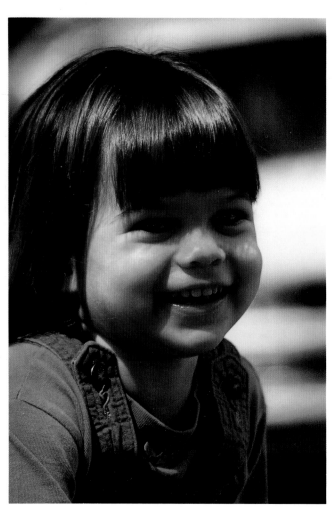

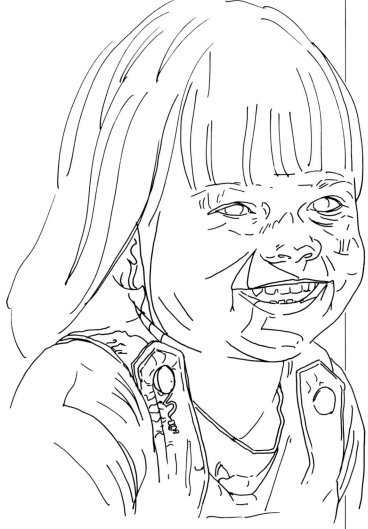

COLOR PALETTE

Burnt Sienna

Burnt Umber

Cadmium Orange

Cobalt Blue

French Ultramarine Blue

New Gamboge

Permanent Alizarin Crimson

Permanent Blue

Sap Green

Winsor (or Thalo) Blue

Winsor (or Thalo) Green

3. Undercoating

After tracing the drawing onto watercolor paper, paint Kelly's entire face and neck using a very light mixture of New Gamboge and Permanent Alizarin Crimson. Keep the value light, and be careful not to make this mixture too yellow. Next, undercoat her clothes with a cool Cobalt Blue on her shoulders; add a bit of green for the warmer vertical surfaces.

4. Painting the Shadow Shapes on the Face

When the first wash is dry, paint the shadow shapes on the face. Read these directions first, then prepare the mixtures, referring to the color swatches and diagram; see where each color goes before you paint. Kelly is sunlit, so both the Permanent Alizarin Crimson, Cobalt Blue mixture and the Permanent Alizarin Crimson and Burnt Sienna mixture must be 40 percent darker than the flesh color you have just painted. Use a value scale as shown on page 18 to compare values in the photo with your painting.

Work on dry paper, use plenty of water in your brush and let the colors blend on the paper. Don't go back once a color is put down. There will be time to make corrections later. If the shadow shapes need to be darker, wait for the colors to dry and apply another coat.

Skin appears cooler where the bone is close to the surface, so shadows on the forehead and eyes are cooler than those on the cheeks. Begin by painting the areas of reflected light and work toward the places where the sunlit and shadow sides meet. Lay the colors next to one another so their edges touch. Begin the edge of Kelly's forehead over her left eye with the mixture of Sap Green and New Gamboge, followed immediately with the Winsor Green, Winsor Blue mixture, then add Cobalt Blue, ending with the violet mixture

Warm and Cool Colors

Warm colors are those in which red, orange and yellow predominate. Cool colors are those in which blue, green or violet predominate.

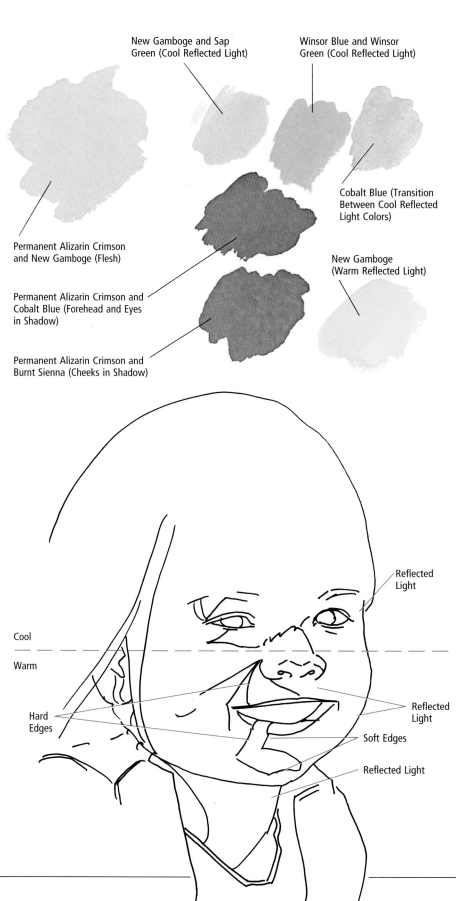

New Gamboge and Sap Green (Cool Reflected Light)

Winsor Blue and Winsor Green (Cool Reflected Light)

Cobalt Blue (Transition Between Cool Reflected Light Colors)

Permanent Alizarin Crimson and New Gamboge (Flesh)

New Gamboge (Warm Reflected Light)

Permanent Alizarin Crimson and Cobalt Blue (Forehead and Eyes in Shadow)

Permanent Alizarin Crimson and Burnt Sienna (Cheeks in Shadow)

Cool

Warm

Hard Edges

Reflected Light

Reflected Light

Soft Edges

Reflected Light

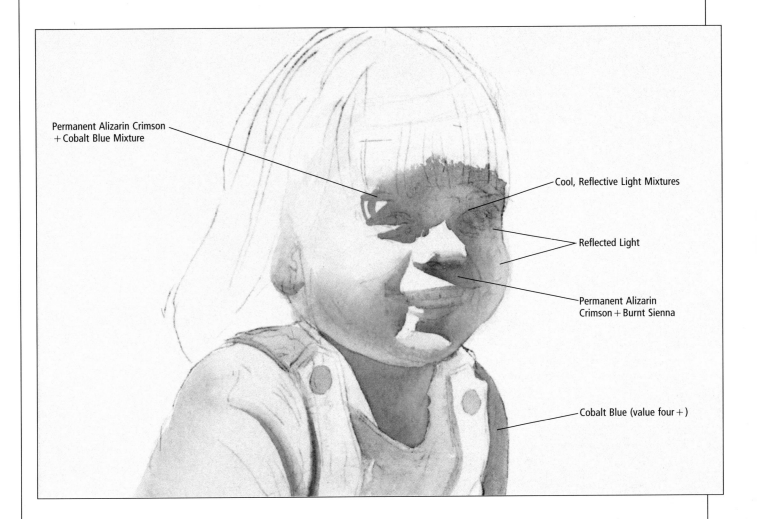

Permanent Alizarin Crimson + Cobalt Blue Mixture

Cool, Reflective Light Mixtures

Reflected Light

Permanent Alizarin Crimson + Burnt Sienna

Cobalt Blue (value four +)

(Permanent Alizarin Crimson plus Cobalt Blue). You might want to stop here and let the colors dry before finishing the left side of her cheek. If you do, stop at the edge of the bottom eyelid.

Now paint the warmer shadow shapes on her cheek and chin. Begin with New Gamboge (reflected light) along the outside of her cheek and under her chin. Immediately add the Permanent Alizarin Crimson and Burnt Sienna mixture. Soften all rounded edges. The only place you must maintain a 40 percent value difference is where sunlit and shadow sides meet. Let everything dry before you go back to make any corrections. While the color on her face is drying, use Cobalt Blue darkened with French Ultramarine Blue (value four plus) to paint the shadow side of her shirt.

Reflected Light

Reflected light is just that—light. It may appear on the shadow side of objects due to the reflection of light from an adjacent object that is in full sun. The color of the light depends on the color of the object that reflects it. This knowledge becomes an "open sesame" to the artist in search of color. You are the one who can decide which colors are reflected. I used many colors to suggest the reflected light on Kelly's face.

With watercolor pigment, the trick of suggesting reflected light in a convincing manner is all in the water. Too much water and the color will spread in a weak puddle, and you'll lose the intensity of the color. Not enough water and the color will streak. It takes practice to blend smoothly from light to dark values, so practice this water/pigment ratio on scraps of watercolor paper first.

5. Continuing the Face and Clothing

Continue painting the face using various values of the same colors you have on your palette to accent the facial planes on both the sunlit and shadow sides of Kelly's face. To suggest the dental arch, put a dot of neutralized blue-gray pigment in the corners of her mouth and pull the color together with water so the color appears darker at the corners. I use a mixture of Burnt Sienna and Cobalt Blue for this purpose. With the exception of very young children, it's best to avoid painting between teeth. Kelly's only three years old, so let's use a dark red mixture of Permanent Alizarin Crimson and Burnt Umber to paint the inside of her mouth, between her teeth, and her nostrils. When you paint her shirt remember that her back, facing the light, will be slightly warmer (more toward green) than the color on her shoulders. Use French Ultramarine Blue to paint her overalls. The cast shadow across her shoulder is blue-violet made by mixing French Ultramarine Blue with Permanent Alizarin Crimson. Use these same colors to paint the dark shadow under the other shoulder strap. Be sure to allow for the thickness of the top edge of her shirt collar.

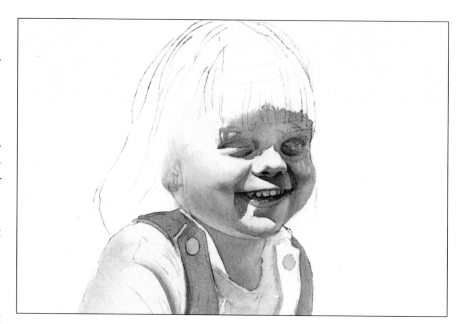

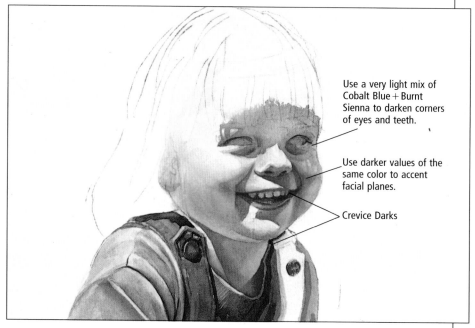

Use a very light mix of Cobalt Blue + Burnt Sienna to darken corners of eyes and teeth.

Use darker values of the same color to accent facial planes.

Crevice Darks

6. Painting the Hair and Background

Wet the entire hair area and well into the background with clear water. Use New Gamboge, Cadmium Orange and Burnt Sienna for the sunlit areas and add Permanent Alizarin Crimson and Winsor Blue for the areas in shadow. Add colors one at a time following the direction the hair grows; you need little water on your brush because the water is on the paper. Paint almost to the outline of the hair and let the color flow slightly into the premoistened background area. Be sure you have a 40 percent difference in value between the sunlit and shadow sides of the hair. Continue painting only after the hair is completely dry, then re-wet the edges of the hair and the background area with clear water. Add colors one at a time using Winsor Blue, Cobalt Blue, Permanent Blue and Permanent Alizarin Crimson to within about a half inch of the previously painted area. Permit these colors to blend softly toward the edges of the hair. In this way the hair will appear to blend into the background. Avoid hard edges when painting hair. Notice I let some of the warm background color flood over the shirt to soften the edges of the shoulder and unify the colors.

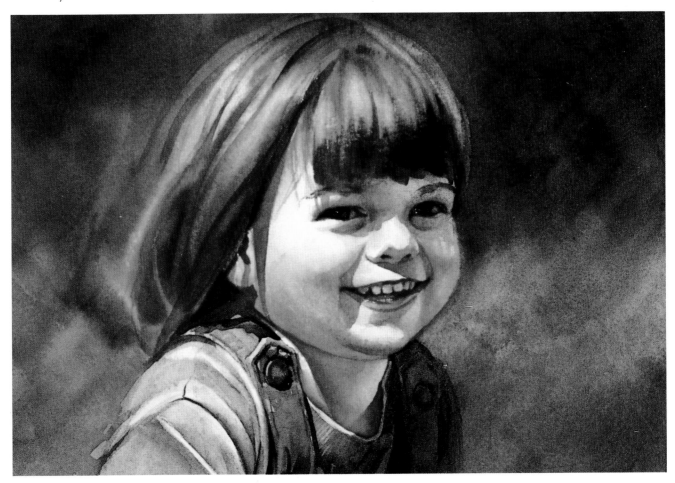

Twin Tulips

1. Studying the Photo

This photo makes a nice painting without any changes. The two red tulips in the foreground are strategically located to become the focus of the painting while the white blooms draw your eye across the picture area. Notice that sunlight penetrates a few of the petals, enhancing the color of adjacent ones. Care must be taken to prevent the white tulips in the top left corner from drawing the eye out of the picture area. The white flowers in shadow don't present a color problem, but you may want to make a few trial color swatches before you paint the dark background area.

2. Transferring the Drawing

I used an opaque projector to enlarge this photo onto a piece of tracing paper; then I traced the drawing onto the watercolor paper, connecting shapes and making corrections.

3. Darkening the Corners

Solve the problem of keeping the viewer's eye within the picture area by darkening the corners of the watercolor paper. Wet the entire paper and paint around the edges using Cobalt Blue and Rose Madder Genuine. Apply colors one at a time and let them blend on the paper.

4. Enhancing Light and Shadows in Background Tulips

While the paper is drying, study the white tulip in sunlight nearest the top right. Think about what happens to the color temperature of objects in sunlight; the vertical petal behind the stamen does not directly face the light, so it's slightly cooler in color temperature than the petal facing it. To enhance this color temperature difference, dampen the surface of this oblique petal and paint a very pale

blue in the area away from the source of light as shown here. Then repeat the process on the sunlit petal, only this time use a very pale yellow. These are subtle differences, and you have to be careful not to add too much color. Once you get the idea, your flower painting may have a great deal more depth.

Even some of the white tulips seem to have pink in their petals, so let's paint the cast shadows with Cobalt Blue along the leading edge where the shadow meets the sunlit area, and warm the color with Rose Madder Genuine away from the source of light.

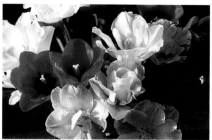
1. Studying the Photo

The stamen comes next. Avoid the sunlit top and paint the sides with New Gamboge. Notice that the shadow cast by the adjacent petal falls across the lower part of the stamen, turning it green. To complete the flower use Rose Madder Genuine and Cadmium Orange.

Paint the entire pink tulip in shadow with a mixture of Cobalt Blue and Rose Madder Genuine. Bring the color into the background to suggest the sunlit areas on the two red tulips behind this one. When the paint has dried, use a mixture of Permanent Alizarin Crimson and French Ultramarine Blue for detail.

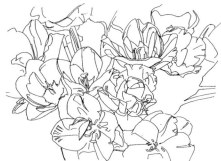
2. Transferring the Drawing

3. Darkening the Corners

COLOR PALETTE

Burnt Umber

Cadmium Orange

Cadmium Red

Cobalt Blue

French Ultramarine Blue

New Gamboge

Permanent Alizarin Crimson

Permanent Rose

Raw Sienna

Rose Madder Genuine

Scarlet Lake

Winsor (or Thalo) Blue

Winsor Red

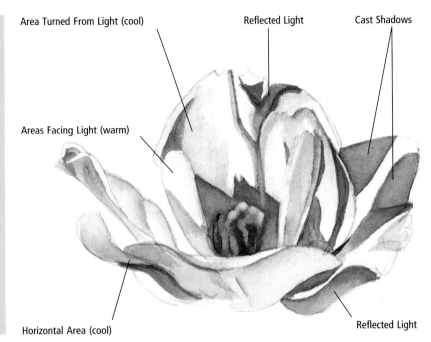

Area Turned From Light (cool)

Reflected Light

Cast Shadows

Areas Facing Light (warm)

Horizontal Area (cool)

Reflected Light

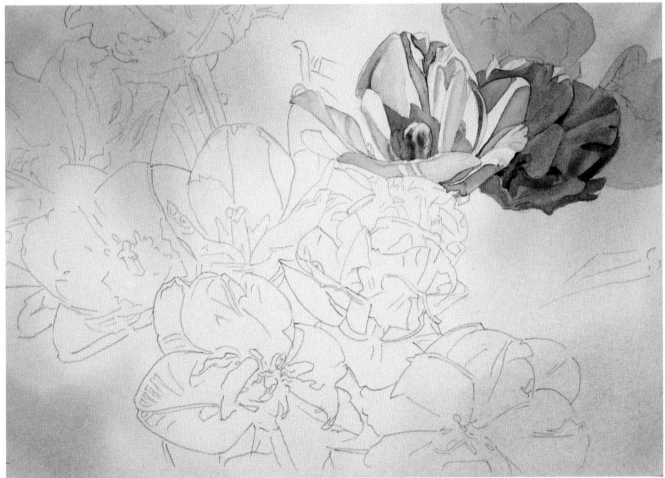

4. Enhancing Light and Shadows in Background Tulips

5. Filling in More Tulip Shapes and Colors

The white tulip in the middle is filled with color, and its well-defined shadow shapes add structure and interest. As you paint these shapes, let the various colors mix on the paper. I see Rose Madder Genuine, Permanent Rose, Scarlet Lake and touches of Cadmium Orange, New Gamboge and green; be sure to use a warm dark color such as Permanent Alizarin Crimson and Burnt Umber in the crevices at the base of the petals. Use Permanent Alizarin Crimson for most of the shadow shapes on the two red tulips in the background. In the darkest places you may need to add Winsor (or Thalo) Blue but keep the mixture toward red.

To make sure the tulip at the bottom right does not detract from the central flowers, undercoat the entire surface with a wash of Cobalt Blue. While the paint is still wet, add a touch of Raw Sienna at the center. Once everything is dry, moisten the petals one at a time and add Rose Madder Genuine near their tips. To complete the detail and set some petals back, use a mixture of Cobalt Blue and Rose Madder Genuine.

Permanent Alizarin Crimson + Winsor Blue Mixture

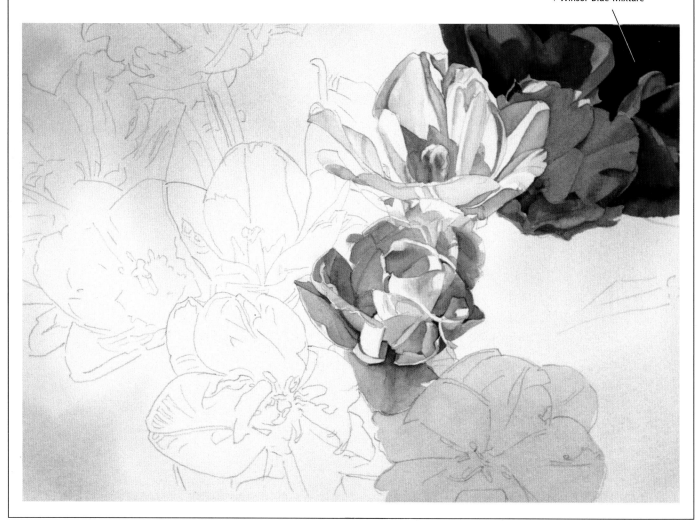

6. Coloring in the Background

The dark background colors on the right act as a foil for the tulips in sunlight as well as help define their edges; use colors with a wide value range that contain very little black in order to avoid mud. The background color in the top right corner is Winsor Blue and Permanent Alizarin Crimson mixed on the paper.

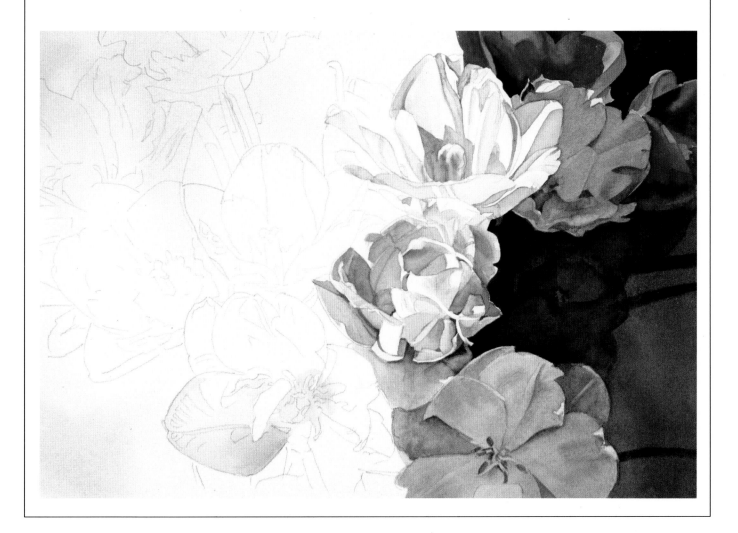

7. Adding a Variety of Colors

You can see light penetrating the outer petals of the remaining foreground tulip as well as some reflected light in the shadow shapes; the cast shadows appear slightly cooler in color temperature where they meet the sunlit areas. Take your time and add a variety of colors as you progress. The red tulip glows with color: Cadmium Orange, Cadmium Red, Winsor Red and Permanent Alizarin Crimson. A mixture of Permanent Alizarin Crimson and Burnt Umber is used near the base of the stamen.

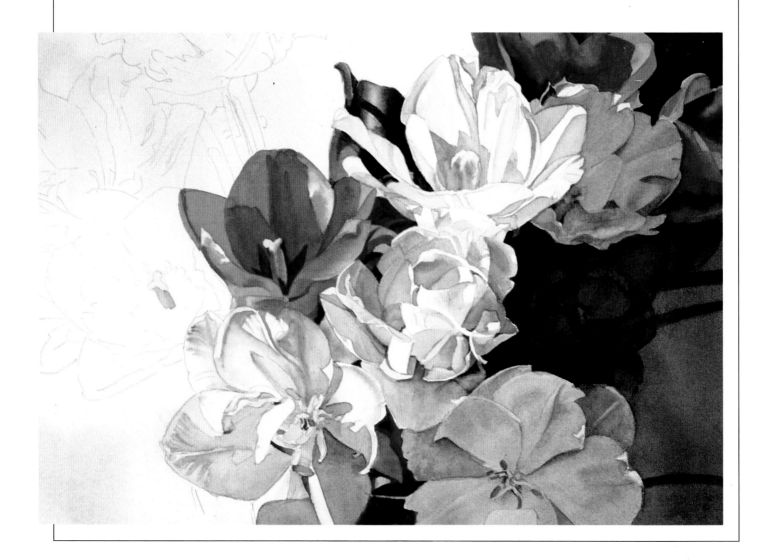

8. Finishing Well

The initial wash has accomplished its purpose of keeping the eye within the picture area, and little detail is needed to suggest the white background tulips. The background and remaining red tulip come last. Don't forget to take advantage of the reflected light on the stamen and lower petals. Think you're finished? Check to be sure you've left no careless edges. Grandmother had it right when she said a thing worth doing is worth doing well. I hope you're pleased with your painting. If not, put it aside and look at it later. It's probably better than you think. If you need to try again, go for it. All of us who paint have had our share of disasters, but that's how you learn!

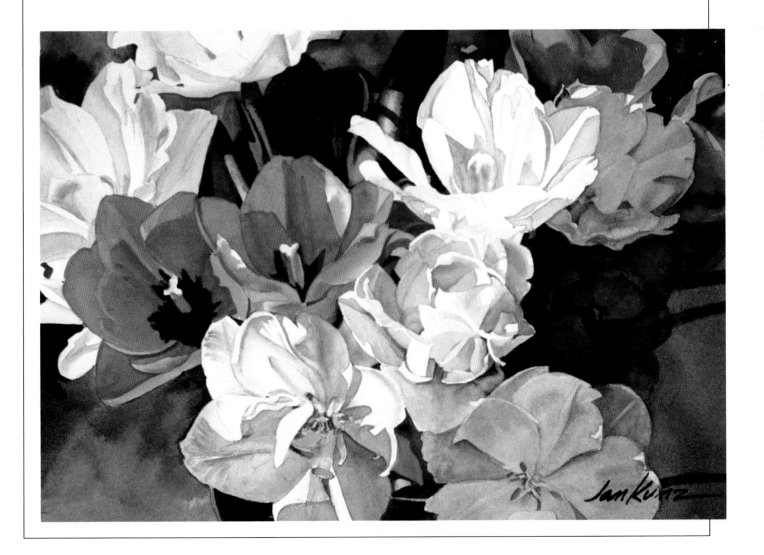

Running Horse

1. Studying the Photo

Whenever you decide to paint, the first question you ask yourself is, "What do I want to communicate to my viewer?" The beautiful horse in this photograph seems to dance off the page, but the rest of the photograph is static and uninteresting. The goal in this painting is to share a sense of movement and excitement generated by the prancing horse; the pictorial decisions made from now on are calculated to achieve that goal.

This animal needs freedom, so the first step is to eliminate the fences that seem to contain his movement. A vignette format with no definite boundaries will further enhance this feeling. By experimenting with the mini-mat corners, I discovered the sense of movement and tension increases when tilting the picture area so the horse appears to be running down a slight incline.

2. Making an Accurate Drawing

It's best to have an accurate drawing of the horse. He's not difficult to draw if you think of his shape as a collection of cylinders, one each for his head, neck and body, along with smaller ones for his legs. As you can see, there isn't much detail on the body, but I drew a few shapes to locate the planes on his head and back. If you aren't sure of yourself, use this drawing or trace the outline of the horse and enlarge it to a paintable size on a photocopier.

3. Choosing a Background

Now decide on a background. Certain shapes seem to evoke emotions; for instance, we associate vertical and horizontal shapes with stability and strength. While curvilinear shapes may make us feel relaxed and comfortable, diagonal shapes and lines can create a feeling of tension and excitement. The choice is clear: the dancing horse belongs on a background of exploding color and diagonal shapes.

Warm up for this painting by wetting a scrap piece of watercolor paper and painting streaks of color diagonally across the page. Think about flying dust and sand, and put energy into your brushstrokes. Don't stop until you feel confident you can command your brush into violent action. Use any colors that make you think of flying dirt. I used Burnt Sienna, Burnt Umber, Cadmium Orange and Cobalt Blue mixed with Permanent Alizarin Crimson. Experimenting is fun, and it may help you make a more exciting painting.

4. Painting the Background

After you transfer the drawing onto the watercolor paper, wet the entire surface and, beginning at the horse's feet, paint the explosive streaks of color you have been practicing. As you paint, try to imagine kicked-up dirt flying through the air and across the horse's legs and feet. Pull some Winsor (or Thalo) Blue and Green, along with a touch of Cobalt Blue, into the background to suggest sky. Be sure to keep the value light and the edges soft. When you have finished, dry the paper thoroughly before you continue.

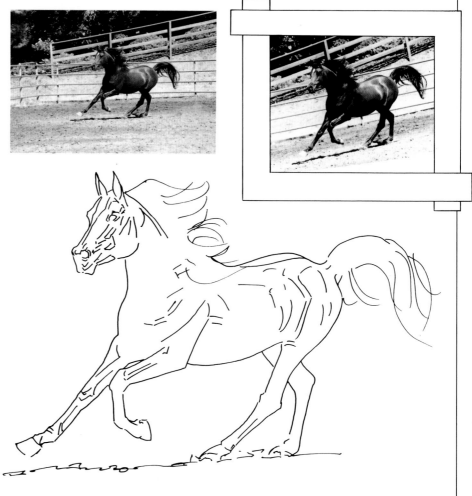

COLOR PALETTE

Burnt Sienna

Burnt Umber

Cadmium Orange

Cobalt Blue

New Gamboge

Permanent Alizarin Crimson

Permanent Rose

Sap Green

Winsor (or Thalo) Blue

Winsor (or Thalo) Green

Practice painting flying dirt.

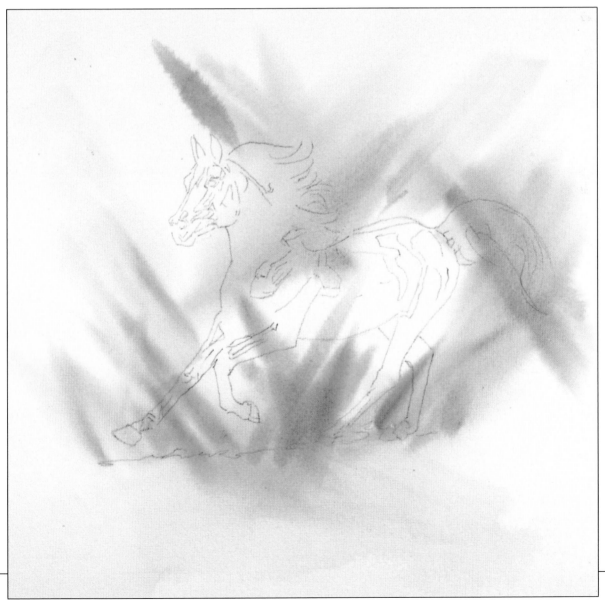

5. Starting the Horse's Head and Rump

Now that the setting is established, it's time to introduce the horse into the scene. Let's take another look at the photograph. Notice the light is almost overhead; therefore, the shadowed underside of the horse's head and belly could be receiving reflected light (even though none is visible in the photograph). The bright highlight on his side becomes slightly cooler as it approaches the top of his back. His coat is a dark warm brown with red-violet shadows, and there are splashes of blue and green in his black tail and mane.

You may want to use a magnifying glass to study the photograph before you paint the horse's head. It's important to locate the eyes and nostrils properly. Don't worry about detail, it's not as important as placement. Use Burnt Sienna, Permanent Alizarin Crimson and Winsor Blue for the dark colors and add touches of New Gamboge to suggest the reflected light under his chin. While the color is still in your brush, put a stroke of New Gamboge along his rump, followed immediately with a mixture of Permanent Alizarin Crimson and Burnt Sienna. Next, paint his upper leg and neck with a mixture of Permanent Rose and Cobalt Blue. This mixture will act as a base for the warm reds to follow.

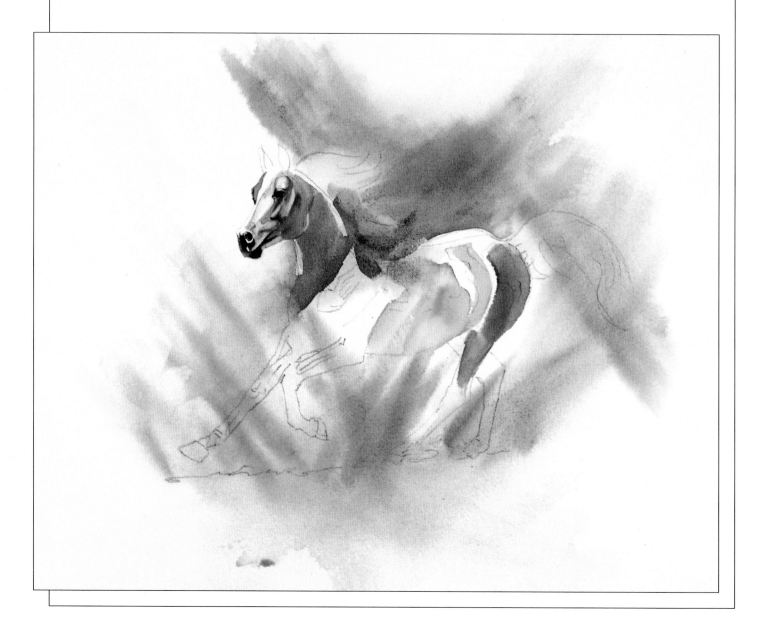

6. Painting the Horse's Body and Legs

When you paint the horse's body, remember you are painting a horizontal cylinder. His back is facing the sky and will be a cool brown, warming on his sides and becoming darker still under his belly, except any area that could be affected by reflected light. I know you don't see it, but let's start with New Gamboge along the bottom of his belly and add a mixture of Permanent Alizarin Crimson and Burnt Sienna. Use plenty of water and add more red to the mixture as you approach the top of his back. Before this passage dries, paint the dark underside of his belly with a dark red-violet, made by mixing Winsor Blue and Permanent Alizarin Crimson. Use some of this same dark red-violet to reinforce the color on the horse's neck.

The highlights on the horse's dark legs are a shiny Winsor Blue. Use a very light value to paint his legs, causing them to emerge from between the previously painted streaks of color. Keep the edges soft to suggest movement.

Reflected Light
(New Gamboge)

Permanent Alizarin Crimson
+ Burnt Sienna Mixture

Cool Red Near Top
of Horse's Back

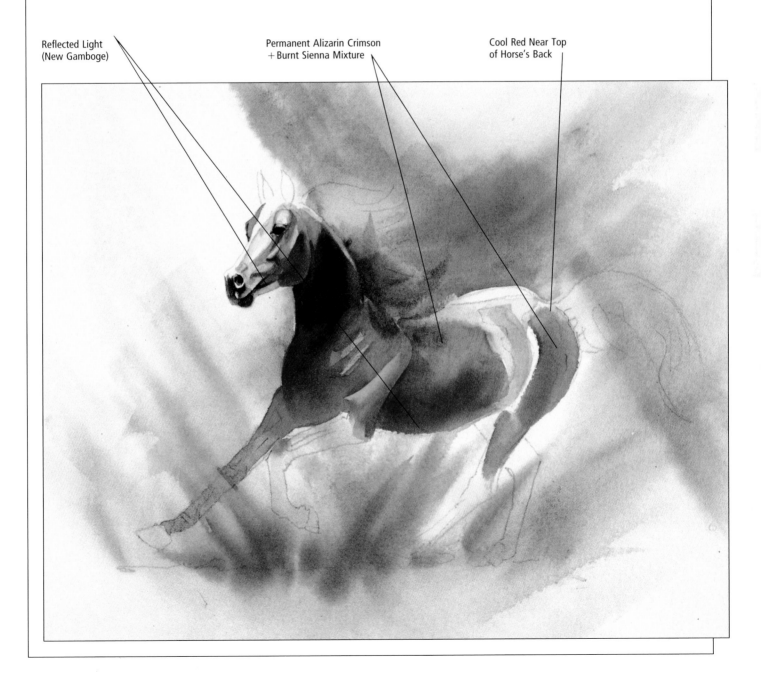

7. Painting the Mane

Black hair can have lots of color. You can often see brilliant streaks of Winsor Blue and Green, New Gamboge, Sap Green and now and then a small swath of Burnt Sienna glistening on the dark surface. To paint the flying mane, wet the area above and a bit beyond the horse's neck with clear water. Now, with only a little water on your brush and plenty of pigment, add colors one at a time, letting your brush follow in the direction the mane is flowing. My favorite brush for this purpose is a ½-inch (12mm) Winsor & Newton Series 995. Try pushing your brush into the paper at the beginning of the stroke and then lifting it quickly as you approach the end of the hair strand.

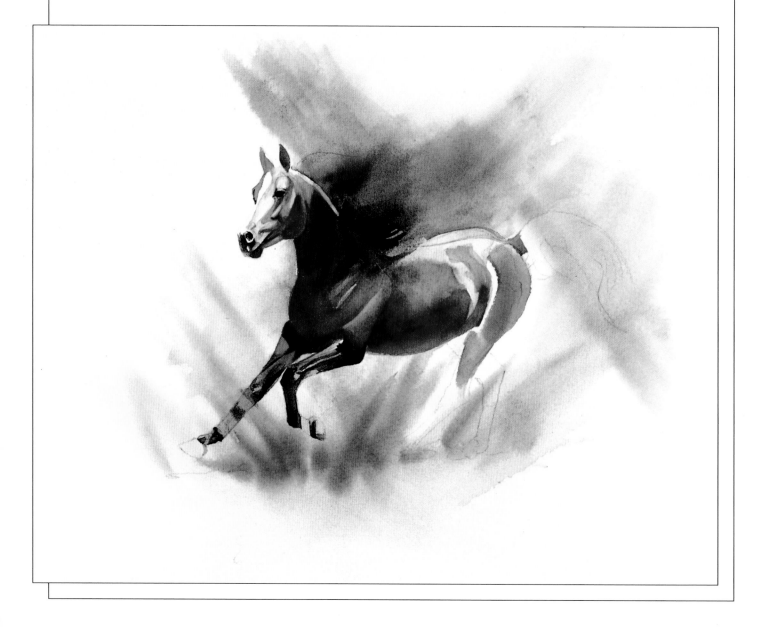

8. Painting the Tail and Final Details

Before you paint the tail, wet the paper and use the same method you used to paint the mane, only this time use a round brush. You may want to switch to a rigger to paint the small stray hairs near the end of the tail.

To suggest clumps of flying dirt, dampen a toothbrush with a dark pigment and drag your thumbnail across the bristle, splattering the color near the horse's feet. Cover the animal's face and any other place you don't want splattered.

Once everything is dry, step back and study your painting. Have you been too cautious? This subject demands boldness and color. Make any needed adjustments.

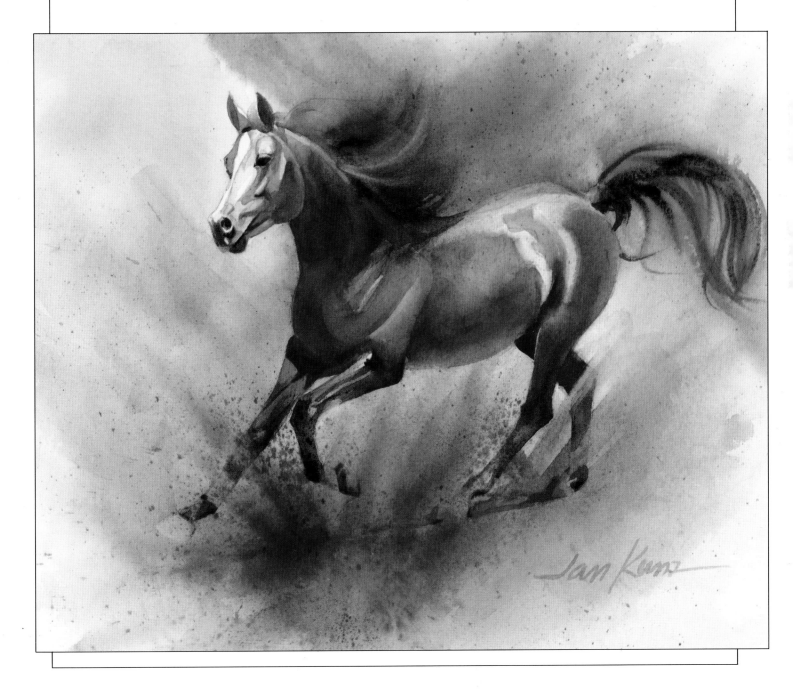

Lilies

1. Studying the Photo

If you find yourself looking for something to paint, try using your mini-mat corners to explore the photos in your file for new painting opportunities. By placing the mat corners at a variety of angles and using different sections of the photo, you might be surprised at the number of new compositions just waiting to be discovered.

Many paintings can be made from this one photograph of lilies. I used the left side of the photo for the top painting, and a section across the top of the photo for the bottom painting.

I used my mini-mats to find still another paintable section for this demonstration. The drawing of this section is shown on the next page.

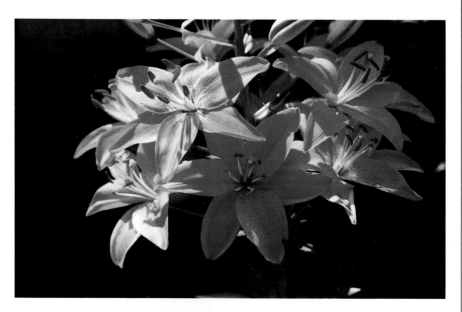

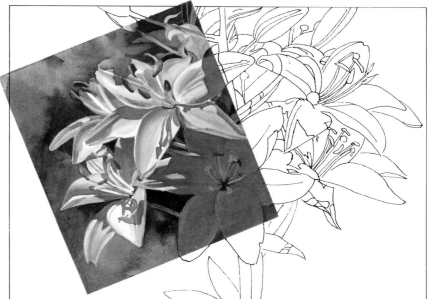

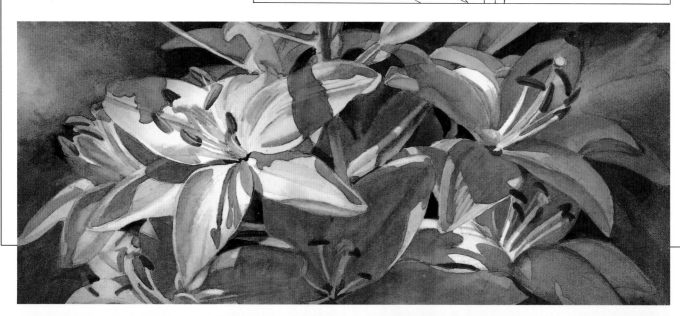

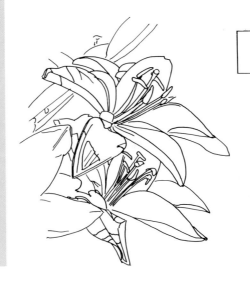

Translucent Light

Cast Shadow

Reflected Light

Area Turned
From Light
(cool)

Area Receiving
Direct Light
(warm)

Reflected Light

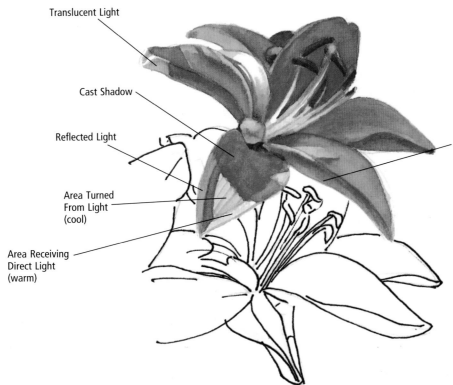

2. Planning the Color Temperatures

The diagram on the left shows color temperature differences. This flower and the one below are on the shadow side of the cluster of blooms, but there are still a few sunstruck places and areas of reflected light. Notice the cast shadow across the bottom petal. Cast shadows receive no reflected light and are 40 percent darker than the sunlit area. I used a cool red (Permanent Rose) where the shadow meets the sunlit area, and then added Cadmium Red Deep near the center of the blossom.

Winsor Red + Cadmium Red

Permanent Rose + Cobalt Blue Mixture

Raw Umber + Winsor Green

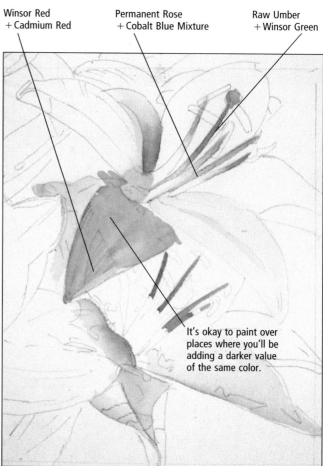

It's okay to paint over places where you'll be adding a darker value of the same color.

3. Painting the Lightest Values

Paint the lightest areas first—if you should miss an edge, spill paint or make some other mistake, you have the opportunity to paint out the error with the darker colors to follow. The stamens in sunlight are near white and appear very fragile—but don't be tempted to paint the parts in shadow too light a value. Consider using a mixture of Raw Umber with Winsor Green on the large styles in the center, and Permanent Rose mixed with Cobalt Blue for the smaller stamens. Remember, even on white objects, the part in shadow is value four (midvalue).

When you have painted the stamens, dry the paper and begin painting the local color of the flowers in sunlight. Keep the value light, and consider checking the diagram to make sure you take advantage of color temperature differences. It's OK to paint over the places where you will add a cast shadow. I used Permanent Rose for the cooler areas and a very pale mixture of Winsor Red and Cadmium Red for the places in direct light.

4. Finishing the Light Areas

Light penetrates the petals at the top left and lower right. This translucent light is darker than the areas in sunlight but lighter than the cast shadows. Underpaint these areas with a warm middle value such as Permanent Alizarin Crimson. You can add the shadow shapes right over this color. The petal in the center is receiving reflected light along the bottom edge. I used Cadmium Red to suggest this warm glow and then added a cooler mixture of Permanent Alizarin Crimson and Winsor Red to paint the rest of the petal. Be sure everything is dry before adding the cast shadows.

5. Painting the Shadow Areas

The cast shadows help define the shape of the flower as well as add interest and color. Paint these shapes one at a time, being careful to follow the contour of each petal. Remember, shadow shapes are a full four values darker than the sunlit area. Use Permanent Alizarin Crimson mixed with a bit of Cobalt Blue where the shadow touches the sunstruck area, and add Winsor Red as it moves across the petal. Making shadows dark enough can be a problem for some beginning painters; be brave and go for it! Remember, the value and the overall shape of the shadows are your first concerns. The nuances of color will become easier to see the more you paint. Any sloppy edges can be corrected with the dark background color.

Translucent Light Cast Shadows Reflected Light

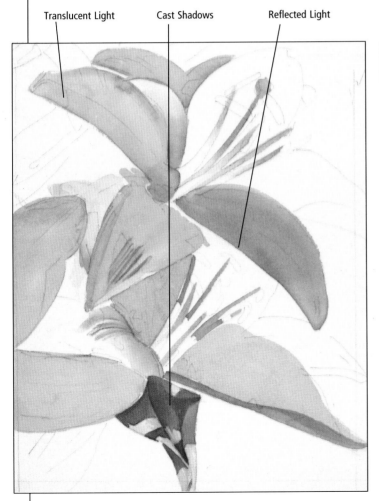

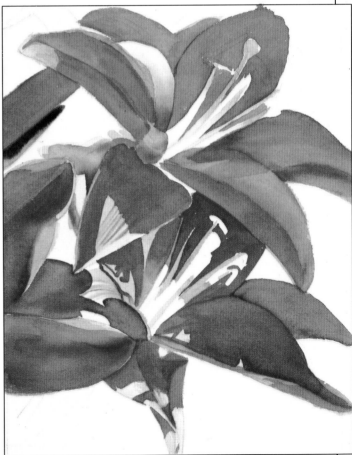

6. Painting the Background

The background is very dark, but it shouldn't become opaque. Begin with middle values of Winsor Blue, Permanent Alizarin Crimson and Burnt Sienna, adding these colors one at a time. As you approach the edges of the petals, darken the value and carefully paint around each shape. Just a few lighter areas in the dark background will keep it looking fluid.

Whenever you use dark values, consider using long-range transparent pigments such as Winsor (or Thalo) Blue and Green or Permanent Alizarin Crimson. If you use an opaque containing black, mix it with a long-range transparent color. In this way you are assured of clean, sparkling, dark colors.

7. Adding the Crevice Darks

Now it's time to add the final detail and the crevice darks. Crevice darks are found between petals and around the base of the stamen, or anyplace where you want to create the illusion of a dark hole. I used a mixture of Permanent Alizarin Crimson and Burnt Umber (toward red) for these shadowed areas.

Check again for value and make any necessary adjustments.

I think this painting works well in either a vertical or horizontal format. You be the judge. I hope you're happy with your painting and decide to make more pictures from this photograph!

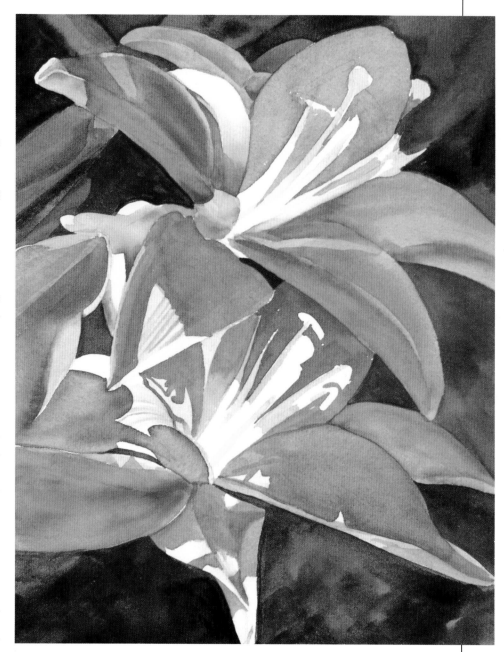

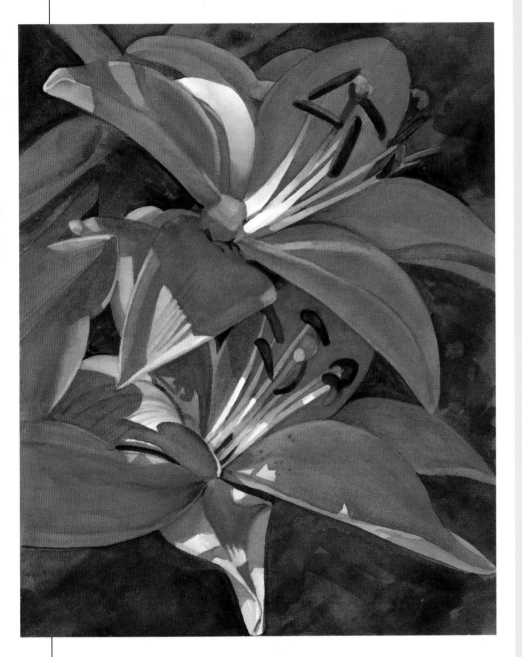

Points to Remember

1 The more careful you are with your drawing, the easier the painting will be. Include all the information you need. By accurately and patiently reproducing the color and value of one small shape at a time, you can paint any complicated object.

2 When planning your composition, consider the emotion certain lines and shapes may evoke in your painting: Horizontal lines suggest stability and strength, diagonal lines create tension and excitement, and curvilinear shapes are soothing and comfortable.

3 Break your subject into its basic shapes, such as a cylinder or sphere, then plan the temperature changes and color values accordingly. For example, even if your camera doesn't capture the reflected light on the underside of a cylindrical horse's body, you know it's there.

4 Squinting your eyes when looking at a photograph will allow you to see the values without the distraction of detail.

5 If you need to make corrections or darken a value, allow the area to dry first.

6 Black hair is made up of a multitude of different colors, from blues and greens to browns.

7 To get clean, sparkling dark colors, use long-range transparent pigments for all dark values. If you use an opaque color that contains black, mix it with a long-range transparent color.

8 Cast shadows help define the shape of the object that creates them, and add interest and color to your painting. They receive no reflected light and should be 40 percent darker than the sunlit areas.

9 When you are finished with your painting, clean up and soften sloppy edges.

3
Painting From More Than One Photo

One sure way to get your creative juices flowing, and ensure an endless supply of painting material, is to create new scenes by combining photographs.

I made sure the light was coming from the same direction by using my Never Fail Nail when I took these three photographs of cactus flowers. Then I rearranged the flowers. I began by tracing the outline of each flower I intended to use, then moved them about until I was satisfied with the new arrangement.

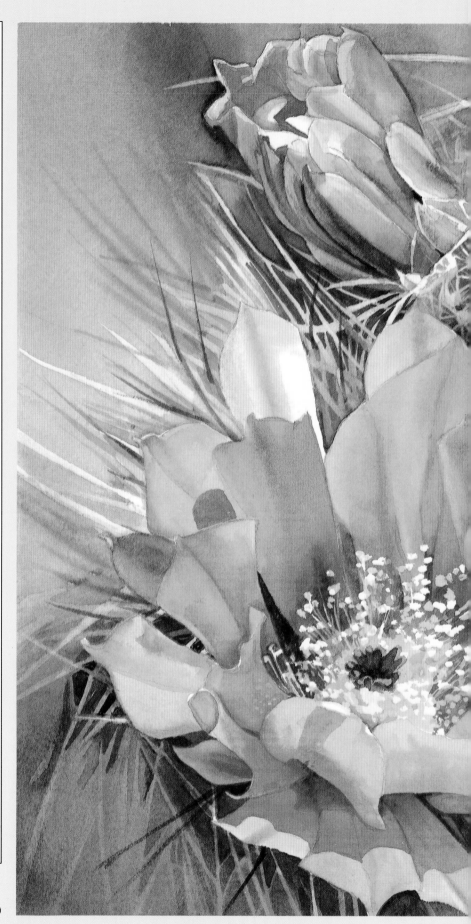

Cactus Flowers, 11½″ × 17″ (29.2 cm × 43.2cm)

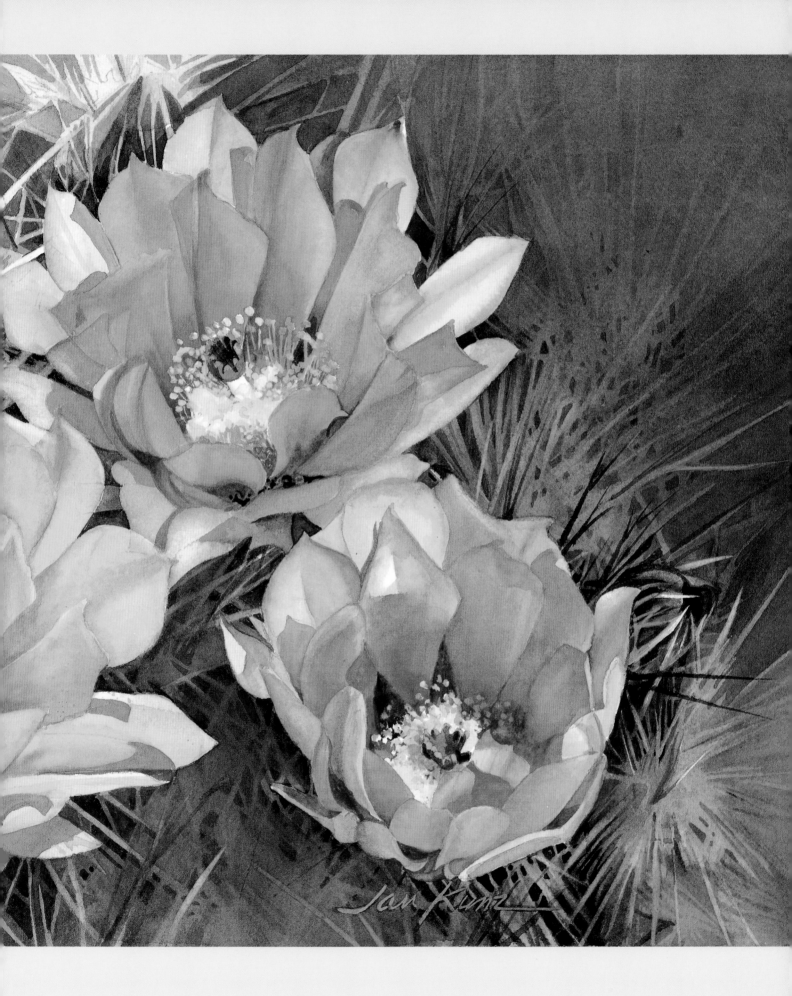

Cowboy and Log House

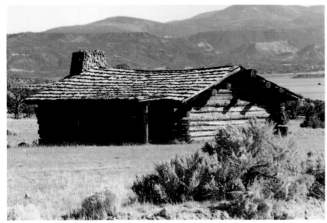

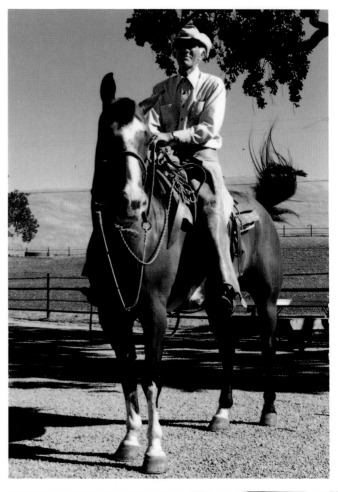

1. Adding New Elements to an Uninteresting Photo

When I took this photo of an abandoned log house at the Ghost Ranch in New Mexico, I thought it would make a good subject for a painting with its sagging roof and cracks around the windows and between the logs. But the house doesn't look as interesting in the photograph as I thought it would. Sometime later, I ran across this photo of Jake in my scrap file. By combining the two photographs I can make an interesting painting.

2. Deciding on Placement and Scale

Whenever you combine two or more photographs you must be sure there is only one source of light and the various pictorial elements are in scale. Even though the photo of Jake and his horse was taken late in the day, and the house was photographed somewhat earlier, it's obvious the light is coming from the same direction. The remaining concerns are placement and scale.

I decided to place the figures in front of the long, dark side of the house to break up that area and add interest. As for scale, the foreground bushes provided the answer: These desert weeds seldom grow much beyond saddle-high, so I measured the height of the horse and rider and determined the saddle is about half the distance from the bottom of the horse's feet to Jake's head. I drew a horizontal line just below the top of the clump of weeds, at saddle level, then used this as the center line to fill in the rest of the mounted figure. Using known elements within the picture area is one of many ways to help you determine scale.

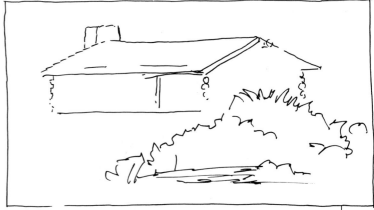

My sketch of the house.

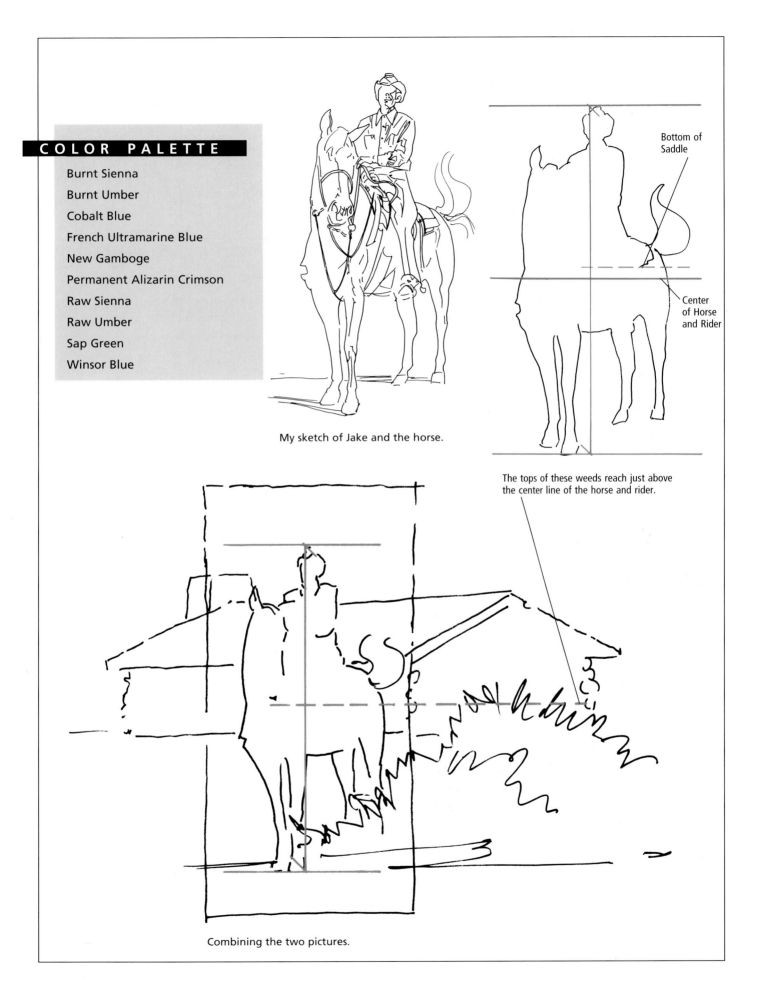

My sketch of Jake and the horse.

Bottom of Saddle

Center of Horse and Rider

The tops of these weeds reach just above the center line of the horse and rider.

Combining the two pictures.

3. Painting the First Washes and Jake

For this demonstration I suggest stretching a piece of 140-lb. (300g/m²) watercolor paper or using 300-lb. (640g/m²) paper. You'll be making large washes and it's easier if the paper stays flat.

First paint the sky right down to the top of the building. Wet the paper and use a large brush to lay in strokes of Cobalt Blue, French Ultramarine Blue and Burnt Sienna, permitting the colors to blend on the paper.

While the sky is drying, let's paint the middle distance and foreground. Since cool colors tend to stay back while warm colors come forward, paint a graded wash with cool colors near the base of the house and blend smoothly to warmer ones in the foreground to create the illusion of distance. Mix a large puddle of Cobalt Blue with a bit of Burnt Sienna. Work on dry paper and use a fully loaded brush. Begin at the base of the house and paint across the entire page. Immediately load your brush again and make another stroke below the first one. Tilt your board slightly so a bead of water forms along the bottom edge of each stroke to insure a smooth passage. Continue down the page in this way, each time adding a bit more Burnt Sienna to warm the mixture. Once the paper starts to dry, don't go back to make any changes; you can always add more color or make corrections later.

Painting sequence is largely a matter of personal choice. I decided to paint Jake's torso next. If you are a bit daunted at the prospect, remember you're painting a series of flat shapes. Jake is wearing a very light blue shirt so the shadow side is midvalue. I painted the entire shadow shape using Winsor Blue and a touch of New Gamboge, added while the color was still damp. Once this color is dry, use darker values of the same color to enhance the details. Jake's face was painted in much the same way. I used New Gamboge along the edge and filled in the rest of the shadow shape with a mixture of Burnt Sienna and Permanent Alizarin Crimson.

4. Painting the Mountains and Foreground Weeds

If you've studied distant mountains, you've probably noticed a layer of ground haze makes them appear slightly lighter in value near their base. To create this illusion of distance, use a large brush and clear water to wet along the bottom of the distant mountain all the way across the paper. Then load your brush with a blue-gray mixture of Cobalt Blue and Burnt Sienna and paint along the ridge, pulling the color down into the wet area at the base. Let the paper dry and repeat the process on the foreground mountain. This time add more Burnt Sienna to the mixture.

While the top of the paper is drying, let's paint the foreground weeds. These bushes look rather scruffy, with clumps of yellow-brown blossoms near the top. Wet the area first and dash in splashes of Burnt Sienna, Raw Sienna, Raw Umber, Permanent Alizarin Crimson and Sap Green. No need to paint them all, just get the feel of their structure.

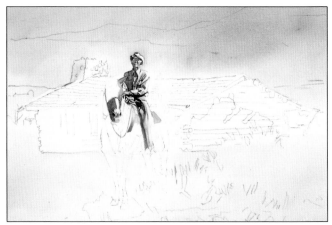

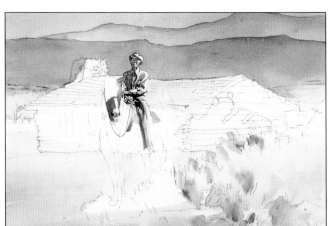

5. Painting the Log Details

There is almost no detail on the front of the house, but the logs are clearly visible on the end wall. We'll start by using a light value mixture of Raw Sienna and Burnt Sienna to suggest the local color of the logs in sunlight. When the color has dried, check the value of the logs and use a color 40 percent darker to paint the cast shadow and the shadow side of the building. I used a warm gray made by mixing Permanent Alizarin Crimson, Burnt Sienna and Winsor Blue. Be sure the cast shadow on the end of the house follows the contour of the logs.

6. Completing the Horse and Rider

Complete the horse and rider using the same method you used to paint Jake's face and shirt. Any time you aren't sure of yourself, try to divide the subject into small, paintable areas and work one section at a time. For example, look at the right side of Jake's horse (our left). That section between the **V**-shaped breast collar and the front wall of the building is one dark flat shape. Use a mixture of Burnt Umber and Permanent Alizarin Crimson here. There is another simple shape on the horse's chest, and still another between the reins and so on. All of the shapes separated by the reins and bridle can be painted one at a time using a mixture of these two colors. You may be amazed at the complicated areas you can paint if you take it slowly, shape by shape.

Be sure the shadow cast by the horse and rider describes their shape and appears to lie flat. Use a brush loaded with a mixture of Burnt Umber and Permanent Alizarin Crimson and try to paint the entire shape in one passage.

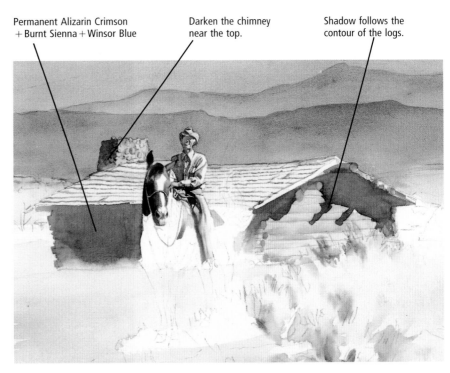

Permanent Alizarin Crimson + Burnt Sienna + Winsor Blue

Darken the chimney near the top.

Shadow follows the contour of the logs.

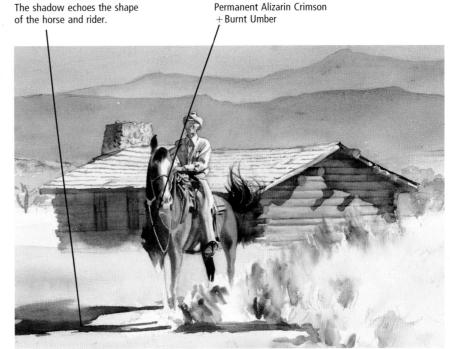

The shadow echoes the shape of the horse and rider.

Permanent Alizarin Crimson + Burnt Umber

7. Checking for Inconsistencies

It's time to make sure there are no obvious problems resulting from the combination of two photographs. To make the horse fit more convincingly into the picture, add some weeds around his feet and in front of his legs, repeating the colors used in the taller bushes: Burnt Sienna, Burnt Umber, Permanent Alizarin Crimson and Sap Green. Since the horse and rider cast a long shadow, be consistent and add long shadow shapes cast by the house and weeds. Use a mixture of Burnt Umber and Permanent Alizarin Crimson.

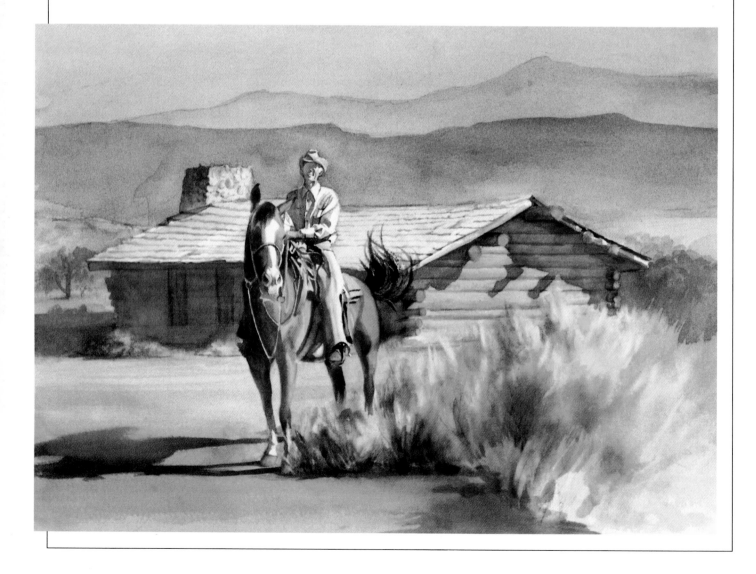

8. A Final Look

Make a final assessment of your work. Remedy any areas that demand too much attention, correct edges and check for proper value relationships.

As you can see, I added crevice darks (Burnt Umber and Permanent Alizarin Crimson) between the logs and under the bushes. Crevice darks are very intense dark reds. This deep color is found in deep holes, open doorways or in any area not affected by the sky. Next I intensified the color in the background mountains with a second coat of the Burnt Sienna and Cobalt Blue mixture. Finally, to suggest texture I used a toothbrush to splatter some Burnt Umber and Raw Sienna into the foreground bushes.

Before you complete a painting it's a good idea to put it away for a couple of days and make your final assessments when you can see it with a fresh eye.

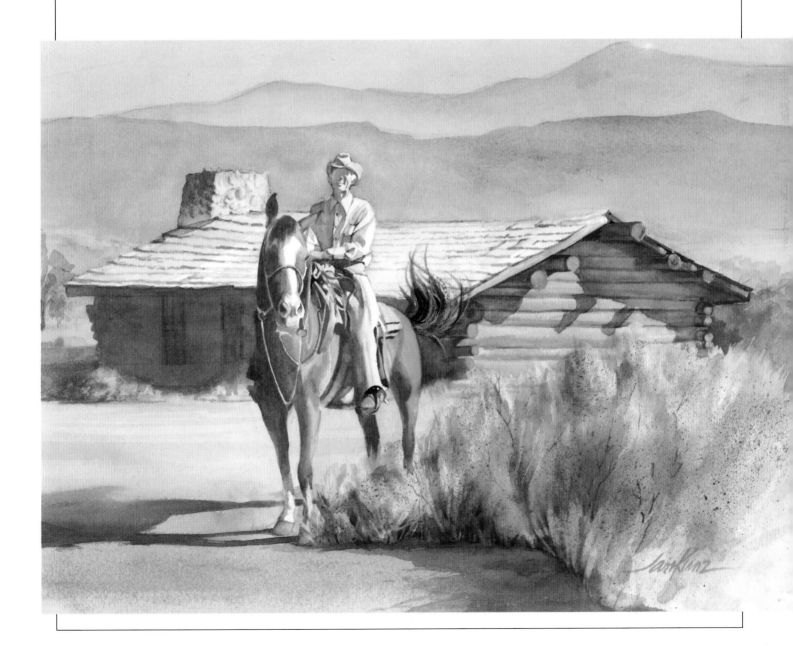

Little Boy and Shady Porch

1. Combining Two Photos

The handsome young man in this photo lives in Bend, Oregon, and the house is one I photographed at San Juan Bautista Mission in California. Together I think they'll make a nice painting, but combining them will require a basic understanding of perspective to solve the problem of relative size, along with a bit of common sense.

Let's start with common sense. The boy is about three and one-half feet (107cm) tall and the height of the door is almost seven feet (213cm). Therefore, if he were to stand immediately beside it, the top of the boy's head would reach to about the center point of the door.

However, the porch is in shade and the boy was photographed in full sunlight, so he should be placed on the path, away from the shadow of the porch. Since objects closer to us appear larger than distant ones, we know the child would appear larger standing on the path than he would next to the door. I suggest you begin by drawing the house onto a piece of tracing paper and mark the spot where you want to place the child. Next, use the method described on page 119 to determine how tall he should be in that location. Draw the boy in proper scale onto another piece of tracing paper. Once you are satisfied, place this drawing into position over the drawing of the house and trace the completed drawing onto your watercolor paper.

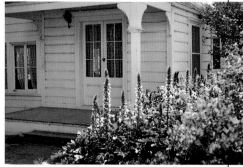

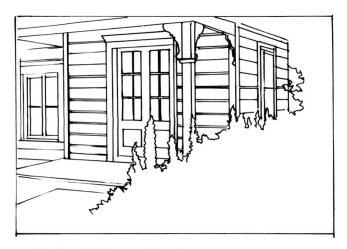

My sketches of the boy and porch.

2. Painting the Porch

Notice what has happened once the boy is located in front of the house. He becomes so large that, if he is to be the focus of the painting, very little of the house remains to be seen.

Again, it is your decision where to start painting, but I began with the porch in shadow. Working on dry paper, I used a large brush to cover the area quickly using Cobalt Blue, New Gamboge and Rose Madder Genuine, being careful to paint around the figure of the boy and the flowers.

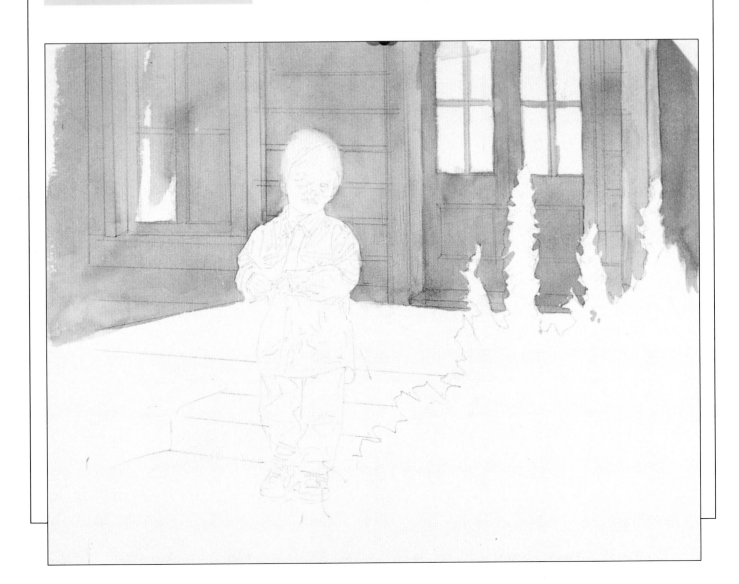

3. Starting the Garden and the Boy's Clothing

Next, I wet the area that was to become part of the front garden and added various colors including Sap Green, Winsor Green, Winsor Blue, Burnt Sienna and Raw Sienna, letting them blend on the paper.

The local color of the boy's shirt and pants came next. I used Cobalt Blue for the shirt and a warm gray for his pants made by mixing Cobalt Blue, Permanent Alizarin Crimson and Burnt Sienna.

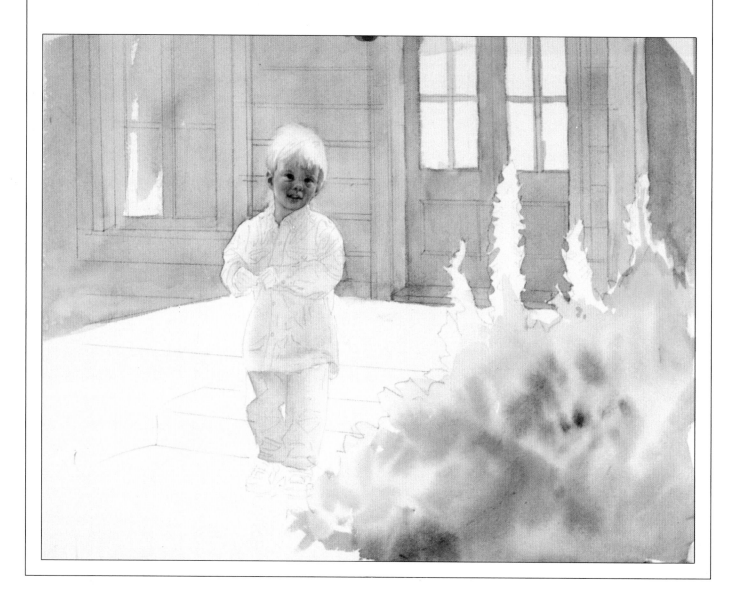

4. Painting the Face

The face is so small you can hardly see how it was painted, so I painted it in again a bit larger. As you know, you can't paint anything exactly the same twice, but these sketches explain the process. I began by painting the entire face with a mixture of Permanent Alizarin Crimson and New Gamboge. I kept this value very light, about number one on my value scale. I waited for this wash to dry before adding the shadow shapes.

Most faces are warm in color temperature around the mouth and cheeks. The area around the eyes, the forehead and the temples are slightly cooler. For the warm areas in shadow, I mixed Permanent Alizarin Crimson and Burnt Sienna. For the cooler areas I used a mixture of Permanent Alizarin Crimson with just a touch of Cobalt Blue. Because his face is in shadow, these colors had to be much darker in value (value five), as you can see by the color swatches.

To suggest the reflected light across his chin and under his nose I used New Gamboge, then added a bit of Sap Green to the New Gamboge for the reflected light under his eyelids. After wetting the hair area with clear water, I streaked in a few brushstrokes of Burnt Sienna, New Gamboge and Raw Sienna, adding the colors one at a time.

After everything dried, I used another coat of these same colors to enhance the facial planes. I darkened his cheeks and neck and the inner part of his ears. Finally I mixed Cobalt Blue and Burnt Sienna and darkened the corners of his eyes.

All that remained to finish painting his face was to add the final darks. I used a mixture of Burnt Umber and Permanent Alizarin Crimson to paint inside his mouth and nostrils. I added a touch of Cadmium Red to the tip of his nose, and darkened the hair around his face with Burnt Sienna.

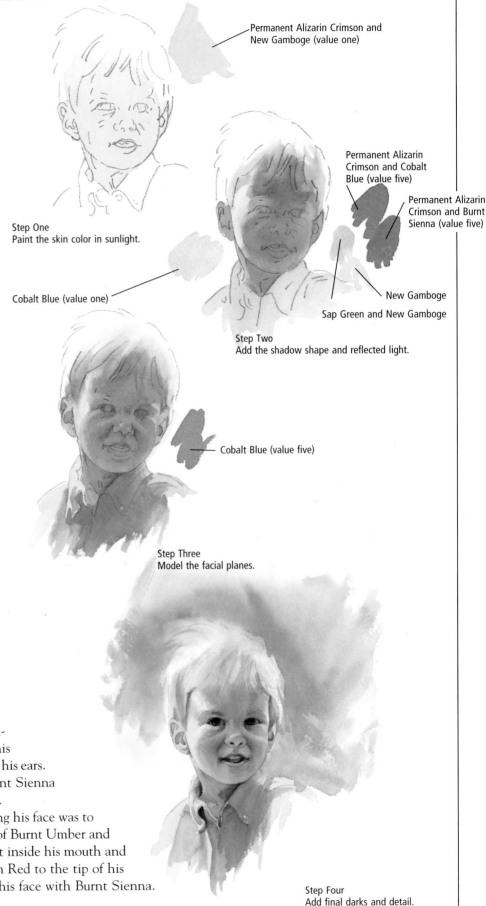

Permanent Alizarin Crimson and New Gamboge (value one)

Step One
Paint the skin color in sunlight.

Permanent Alizarin Crimson and Cobalt Blue (value five)

Permanent Alizarin Crimson and Burnt Sienna (value five)

New Gamboge

Sap Green and New Gamboge

Cobalt Blue (value one)

Step Two
Add the shadow shape and reflected light.

Cobalt Blue (value five)

Step Three
Model the facial planes.

Step Four
Add final darks and detail.

5. Painting the Porch and Clothing

Now let's get back to the house. I painted the porch deck next using a warm gray made by mixing Burnt Sienna and Cobalt Blue with a bit of Rose Madder Genuine. The deck is darker in value than the boy's blue shirt, so I painted carefully around his figure. To paint the path I used the same mixture as on the deck but added more Burnt Sienna.

Next I checked the value of the shirt and painted the shadow shapes and folds 40 percent darker than the sunlit areas, using Cobalt Blue and Winsor Blue. The darkest folds are blue-violet, made by mixing Winsor Blue and Permanent Alizarin Crimson.

The shadow shapes on the child's pants were painted with a mixture of Burnt Sienna, Cobalt Blue and Permanent Rose. Finally, I added a touch of Permanent Rose to the tips of the flowers in the foreground.

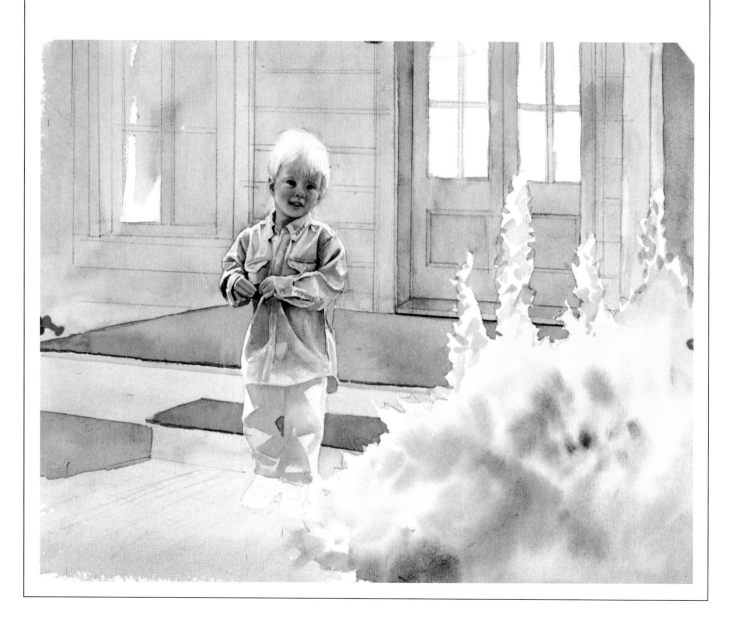

6. Finishing the Painting

To finish the painting I added what my teacher used to call "spinach"—his term for the final touches that add interest to a painting. I used Winsor Green and Raw Umber to paint around petal shapes I envisioned at the base of the flowers, and then I added a few stepping stones to the path by drawing along the edges of the squares with a small brush loaded with a mixture of Burnt Umber and Permanent Alizarin Crimson, followed immediately with a brushstroke of clear water. The curtains were suggested with more of the same blue-gray I used on the porch.

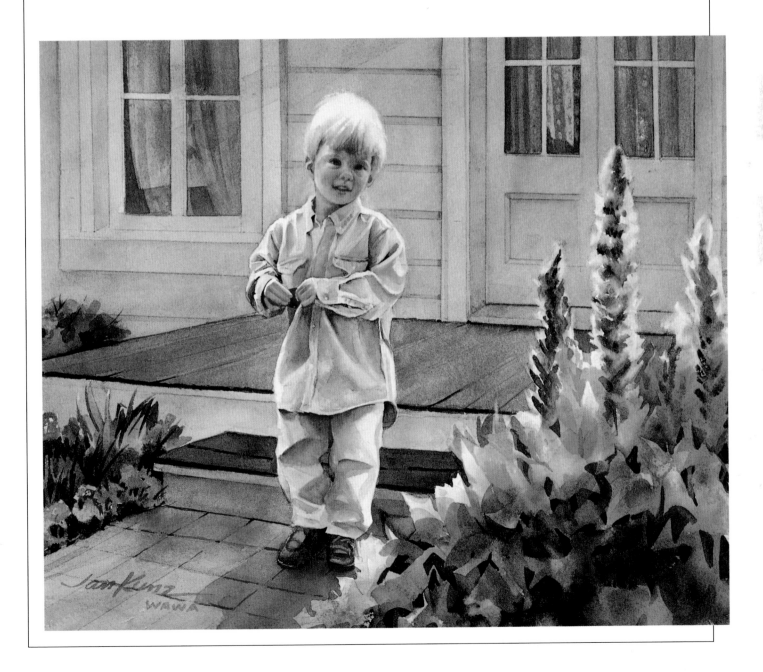

Flower Lady

1. Combining Two Photos

When I found this photograph of a pretty model dressed in a peasant costume, I could imagine her selling flowers in some sunny, romantic setting. This photograph of an ancient mission gateway seemed just like the place I was looking for. I was too close to the mission wall when I took this photo, and I'm sure you have noticed the distortion. However, the largest part of the wall will be hidden by the foreground figure, and what remains to be seen can be corrected by straightening the perpendicular lines of the archway. Scale and perspective are always a concern, but this time I'm more interested in creating a mood than in painting a precise location.

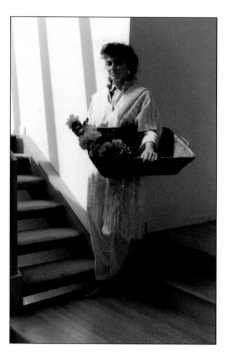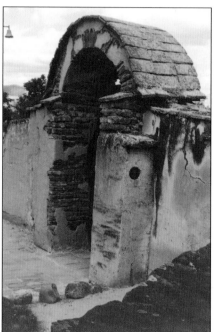

2. Planning the Value Pattern

First decide on the placement of the figure. I used a value sketch to determine I should position the figure so the dark interior of the archway becomes a foil for her face and shoulder. The whitewashed mission wall in the photo is cracked and stained with age. In places the stucco is chipped away exposing the bricks beneath. All this will make an interesting background, but care must be taken not to let these interesting textured surfaces distract attention from the model.

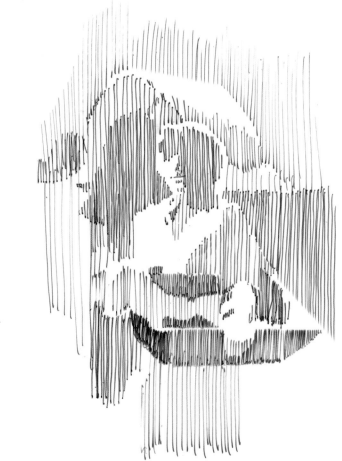

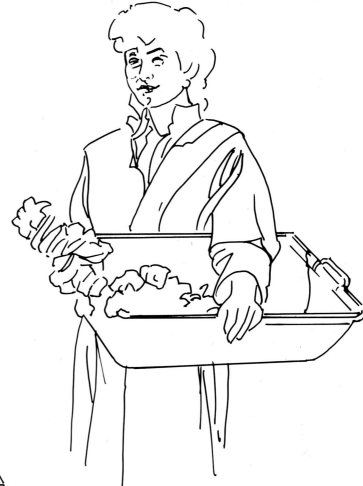

COLOR PALETTE

Burnt Sienna

Burnt Umber

Cadmium Orange

Cobalt Blue

New Gamboge

Permanent Alizarin Crimson

Raw Sienna

Raw Umber

Rose Madder Genuine

Sap Green

Winsor Blue

Winsor Red

Various greens

3. Making Detailed Drawings

I drew the figure in the correct scale on one piece of tracing paper and the arch on another. When I was satisfied with both, I overlayed the figure sketch onto the one of the mission wall before tracing only the lines I wanted onto the watercolor paper.

4. Painting the Background and Sunlit Skin

Once you have the drawing in place, mix a big puddle of Cobalt Blue and use a large brush to paint the entire background, omitting only the figure of the woman. As you paint, add other colors such as Rose Madder Genuine and Winsor Blue. Use plenty of water, and keep the entire surface wet to avoid bleed-backs, those hard-edged blossoms that have a nasty way of appearing when the paper doesn't dry uniformly. If you feel more comfortable, pre-wet the area before you begin.

When this wash is dry, paint the sunlit side of the model's face, neck and arm. Use a mixture of New Gamboge and Winsor Red, keeping the value light.

5. Painting the Clothing and Head

Next, paint the sunlit side of the clothing, and when it has dried, add the shadow shapes. Use Raw Sienna for the pale yellow scarf in sunlight and Raw Umber with a few touches of Burnt Sienna to paint the shadow shapes defining the folds across her shoulder. As you paint, check that you have made the shadows 40 percent darker than the sunlit areas.

The pink shirt is Rose Madder Genuine in sunlight and Permanent Alizarin Crimson in shadow. Be careful of the edges when you paint the shadows across the model's face. Use a cool mixture of Permanent Alizarin Crimson and Cobalt Blue around her eyes and forehead and Permanent Alizarin Crimson and Burnt Sienna for her cheeks. The steps for painting this woman's face are the same as those shown on page 73 of the previous demonstration.

After her face has dried, paint her hair wet-into-wet using Sap Green and Raw Umber on top and adding Burnt Sienna and Permanent Alizarin Crimson on the vertical surface and near her face. You may wonder why I use so much color in hair. The sunlight bouncing off the shiny surfaces can create colorful, radiant effects, and since horizontal surfaces are cooler than vertical ones, I try to include all the wonderful colors you might see on dark brown hair.

6. Starting the Wall and Flowers

Mix a warm gray from Burnt Sienna and Cobalt Blue to paint the face of the mission wall. While this wash is still wet, add several gray streaks to suggest the mildew clinging to the wall. Dab in color just under the overhanging tiles and let it run down the wet surface.

When the wall is dry, paint the interior of the archway. Work on dry paper using a fully loaded brush, being careful to avoid the foreground figure. Add Rose Madder Genuine, Burnt Sienna and Winsor Blue one at a time so they will combine on the paper to make an interesting gray. When you're finished, don't forget to check the value relationships. It's important to be consistent throughout the painting.

Finally, paint the colorful flowers in the woman's basket using Rose Madder Genuine, Cadmium Orange, New Gamboge and various greens.

7. Painting the Bricks

Before you paint the bricks, take a careful look at your drawing—it may be a good idea to reinstate any lines obscured by layers of paint. The rows of bricks inside the archway should align with those of the roof tiles. It's easier to make a row of bricks look old if you paint them one at a time. Use a variety of colors: Burnt Umber, Burnt Sienna, Permanent Alizarin Crimson, Sap Green and Raw Sienna. The sketch of the bricks and stucco at right shows a detail of the wall. Make allowance for the thickness of the stucco where it falls away, exposing the bricks beneath.

While it's important to know how the wall would look on close inspection, keep the area simple so as not to draw attention away from the foreground figure. If the bricks are

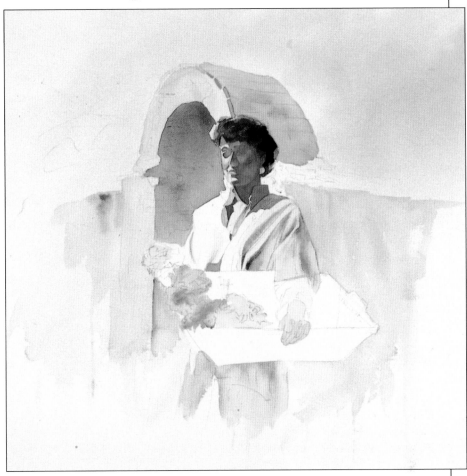

The stucco wall has dimension.

A wash of Cobalt Blue will help keep the bricks from becoming too important.

Paint bricks one at a time, using plenty of color.

becoming too important, use Cobalt Blue diluted with plenty of water to paint over the entire wall and archway. Use a light touch so as not to pick up any of the color underneath. If the wall still demands too much attention, dry the surface before repeating the process.

8. Finishing the Painting

Before painting the basket, give definition to some of the flowers and add a few green leaves. When everything is dry, paint the basket itself using various strokes of Permanent Alizarin Crimson, Burnt Sienna and Burnt Umber, being careful to avoid the flower shapes.

Before I go any further, I see an error that needs correction. I have made the bottom of the model's ear too high. Her face is slightly above our eye level so the bottom of her ear should appear slightly below the level of her nose. To solve this problem, I use a soft brush moistened with clear water to gently dilute the color under her ear, then dab it out with a piece of tissue. After the area dries, I need only reinstate the dark hair a bit lower around her lengthened ear to correct the problem.

The final step is to study your painting and ask yourself if you have created a peaceful, sunny mood. Is the background too dominant? The mission wall is interesting, but this painting is about a woman selling flowers, not a mission wall. I know from experience that now and then you'll paint a beautiful passage and want to keep it, even though it does nothing for the final painting. If something doesn't work, be ruthless and paint it out. I know it hurts, but your painting will be the better for it!

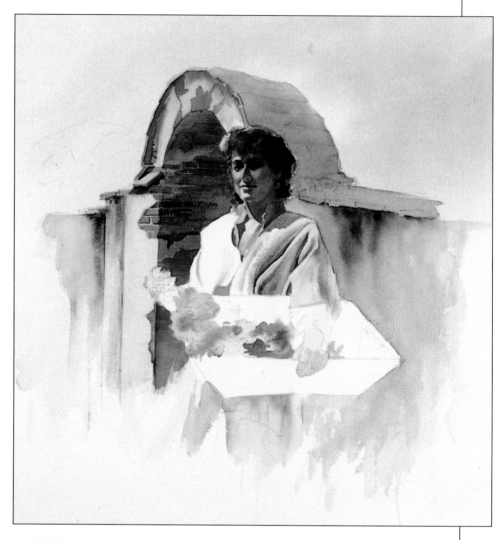

Points to Remember

1 Divide complicated subjects into small, paintable shapes and work one section at a time. You will be amazed at the intricate detail you can paint if you take it slowly and look for the underlying shapes.

2 Put the painting away for a while before you complete the final details. Looking at it with a fresh eye will help you see what isn't working.

3 Most faces are warm in color temperature around the mouth and cheeks and cooler around the eyes, forehead and temples.

4 Like black hair, shiny brown hair is made up of many different colors whose temperatures are affected by the way each section of hair lays and whether or not they are reflecting sunlight.

5 Don't let background detail draw attention away from the main subject of the painting. If the background becomes too dominant, or if any section of the painting isn't working with the rest of the composition, no matter how beautiful it is, paint it out.

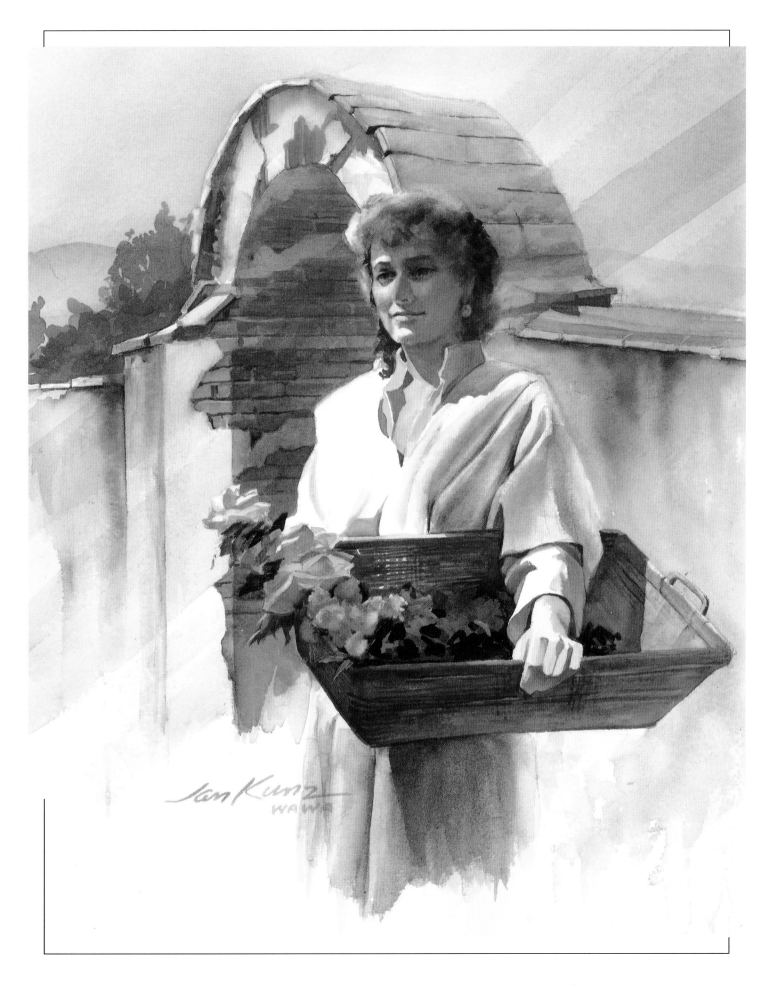

4
Working With Problem Photos

Whether you paint from photos or from life, you have to make choices and be selective about the elements in your painting. Almost any photograph you select as a subject may need some changes. Problem photos often make the best paintings because they force you to think, as well as provide an opportunity for you to grow as an artist. The photos in the following demonstrations are typical of the problems you may encounter.

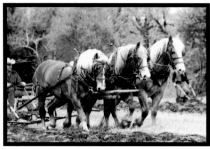

The figure of the plowman on the left side of this photo draws attention away from the horses, which are the subject of the painting. By reducing the value contrasts around his figure, the rider's importance is diminished.

Team Work, 22" × 15" (55.9cm × 38.1cm)

Find Substitutes for Obstructions

1. An Appealing Subject

The first question to ask yourself whenever you begin a new painting is, "Why does this subject appeal to me?" This woman, dressed in soiled homespun, is one of the hostesses at historic Jamestown, Virginia; the thought that she might be one of the hearty people who settled early America is intriguing. Judging by the number of bow ties on her clothing, buttons must have been scarce. Her apron is soiled and her hat is ragged, but her smile betrays her friendly personality. I feel a warmth for this woman I'd like to portray in a painting. But just as the camera clicks, a man steps into the picture.

2. Deciding on Format

I begin my painting by using minimats to locate the picture area I want to paint. A horizontal format eliminates the foreground figure, but I want to show more of her costume so I decide on a vertical picture area.

3. Choosing a Likely Substitution

A substitute for the obstructing figure has to be in keeping with the historical period. I finally decide on wild daisies. It's likely that Jamestown had its share of wildflowers, and daisies seem to go with her sunny face.

4. Making a Value Sketch

Compare values; notice her face is the same value as the shadow on her shirt, and the value of the overblouse in shadow is the same as the background around her head. The flowers are of secondary importance, so their value should be close to that of the apron behind them.

A horizontal format doesn't show enough of the subject's costume.

This vertical format is better, although now I must deal with the obstruction in another way.

In the drawing stage, the man is substituted by a bunch of daisies.

The value sketch.

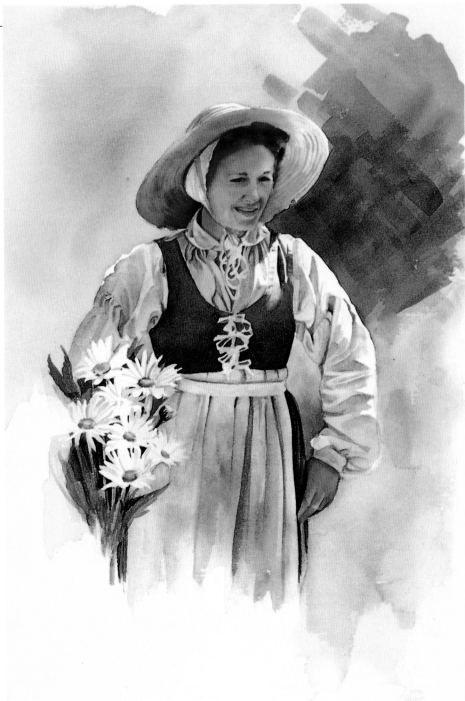

5. Making a Color Sketch
Hues are much like those in the photo; her hat is yellow in front and changes to dark reddish brown at the back of her head. The blue-gray shadows on her shirt contain touches of green and Rose Madder Genuine, and the dirt on her apron is a mixture of Burnt Sienna and Cobalt Blue. Once the daisies and green leaves are added to the color sketch, it seems natural to repeat the green in the background area.

6. Finishing the Portrait
I enlarge the woman's figure onto tracing paper. After making sketches to determine their size, I draw in flowers freehand. Next I use my graphite transfer sheet to trace the sketch onto a piece of 300-lb. (640g/m²) Arches watercolor paper. To control the complicated edges, I work on a dry surface beginning with the lightest values, reserving the darks and final detail until last. To capture the illusion of sunshine, maintain a 40 percent value difference between sunlit and shadow areas on her face and figure. The vignette format adds to the informality of the painting.

Simplify Busy Backgrounds

1. Making a Simplified Sketch

A good painting is composed of well-organized, easy-to-understand shapes, so first simplify the confusing shapes in this photo. I outline the foreground iris onto tracing paper, then sketch in a few stems and leaves using the photograph for reference.

2. Finishing the Painting

Transfer all the information you need from your contour drawing to the watercolor paper so it can act as a guide when you apply color. Many times the subject itself suggests a painting method; for example, where detail is important, it's best to work on dry watercolor paper to control the edges. But this subject requires the soft edges and blended colors of working wet-into-wet (adding wet washes to paper that has first been wet with clear water or a wash of color); detail is added after an initial underpainting dries. I suggest you stretch 140-lb. (300g/m²) paper before working wet-into-wet so it won't buckle or curl; 300-lb. (640g/m²) doesn't need stretching as it is heavy enough to hold the extra moisture.

Although the irises appear white in the photograph, I choose to paint them the delicate light blue I remember seeing in the garden. Study the photograph carefully to spot nuances of color and light. Notice one of the petals on the top flower is backlit; there are numerous places where petals are influenced by reflected light and areas turned from the light are slightly cooler in color temperature than the sunstruck areas. The variety of greens and browns in the stems and leaves work in contrast to the light petals. Keep any background flowers simple and subdued in value so as not to take away from the dominant form.

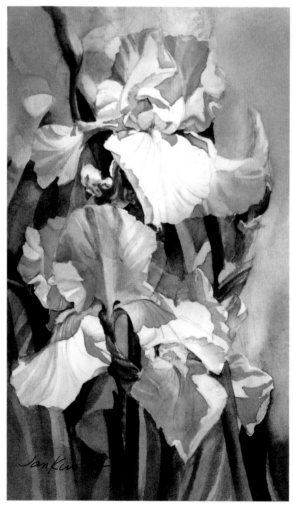

Punch Up Flat Values

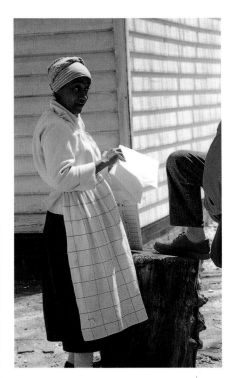

1. Correcting the Composition

That many of the values in this photograph are flat is only one of the problems with this picture taken at Colonial Williamsburg in Virginia. Other problems include removing that disembodied foot and leg, straightening the background wall, and removing the yellow envelope. The white paper looks good, so I decided to leave it. The fact that she's cut off at the ankles also leaves me with an uncomfortable feeling. Even with all these problems, this lady is interesting; I think she makes a great subject.

First, omit the objectionable objects. It's an easy matter to straighten the vertical corner of the building by simply lining it up with the edge of the sketch paper. The baskets come from a photo in my scrap file; they reinforce the vertical shapes and add weight to the bottom of the composition. The baskets also provide a good place to conceal the toes of the subject's shoes. I make sure the baskets are in perspective before transferring the sketch.

The figure and the background area share similar values. The diagonal lines draw the eye out of the composition.

2. Correcting the Values

The shadow sides of the woman's shirt, hat and apron are near the same value as the wall behind her. I darken the value behind her head to bring her more into the foreground. The lines created by the wooden siding seem to lead my eye out of the pic-

By darkening the background, the figure becomes more important.

The dark shapes across the wall stop the thrust of the diagonal lines.

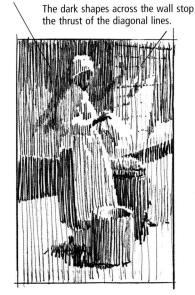

ture, so I add shadow shapes from an imaginary tree located outside the picture area. Value sketches can be a great help in locating and solving such problems before you begin to paint. Don't skip this process.

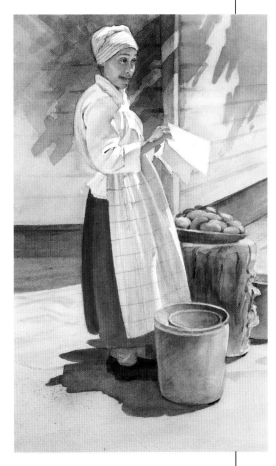

Relocate Competing Subjects

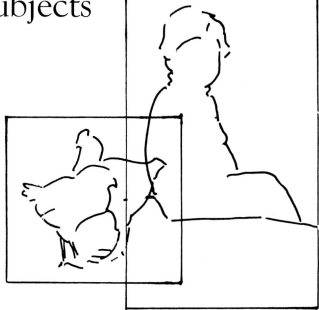

1. Creating One Dominant Form

There are two subjects in this photograph: the chicks and the young man. The young man looks like he's contemplating a future in the poultry business. If we think of pictorial objects as shapes rather than things, it becomes clear that we must overlap the shapes in this photo to create one dominant form.

2. Directing Attention to the Boy

Relocating the chicks improves the composition, but our attention is still divided between the chicks and the boy. This is a story about a boy who likes chickens, so to direct the eye to him and diminish the importance of the chickens, reduce the value contrasts around the chickens.

Crop Out an Awkward Pose

1. Choosing a Photo

Meet Kelly. This little girl lives on a ranch in California where she rides horses. As you can see by the photos at right, she also climbs corral fences. The best way to photograph children is to take a great many pictures in rapid succession when they are unaware of your presence; somehow children at play forget to act silly or even squint in the sunshine. I chose this picture because her expression is natural and unposed, but the position of her body would make an odd painting.

2. Cropping the Photo

By placing the mini-mats at an angle, her face comes into focus. In this new position, the background shapes tend to lead into the corners of the picture area so they have to be relocated to a better position. After the drawing is in place, I paint the skin tone using a light mixture of New Gamboge and Permanent Alizarin Crimson. When the paint is dry, I paint all the shadow shapes including the shadow over her eyes and mouth. Once again I wait for the paint to dry before I add the facial planes and undercoat her blue eyes with Sap Green. The background and her hair are painted wet-into-wet. The final darks and detail are added last.

Limit the Number of Shapes

1. Recognizing an Overcrowded Composition

This photograph and painting provide an excellent example of simplifying the shapes in your photographs. Jake, who is a charmer as well as a real cowboy and poet, posed for our class. You can see from the top line drawing that there are too many shapes in this photo to make a good painting. The bottom drawing shows a simplified composition.

2. Simplifying the Composition

Using a horizontal format and combining areas of equal value reduces the number of shapes. It concentrates the viewer's attention on Jake's face. Some teachers suggest there should be no more than sixteen shapes in a painting; if you're not sure about the number of shapes in your painting, there are probably too many.

Don't Be a Pictorial Blabbermouth!

Years ago my art teacher taught me an important lesson; he suggested we find something to paint behind his garage where some still-life props were stacked. I painted everything in sight and the result was a disaster. Then I saw he had selected only one object to dominate his composition and used just a few other shapes for contrast. The lesson I learned is that you don't have to paint everything just because it's there. Don't make the same mistake I did. Analyze the subject, make choices and, in his words, "Don't be a pictorial blabbermouth!"

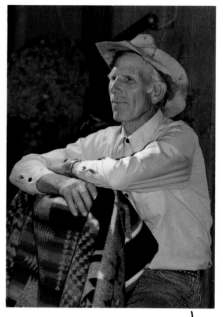

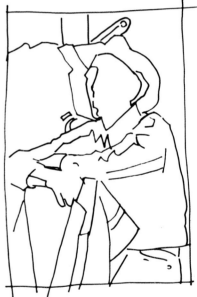

This line drawing was done from the original composition.

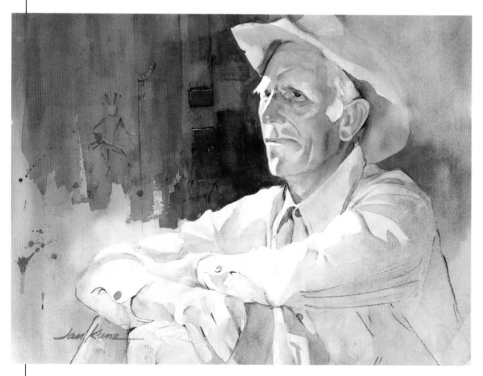

A simplified composition.

Alter Values to Solve Separation Problems

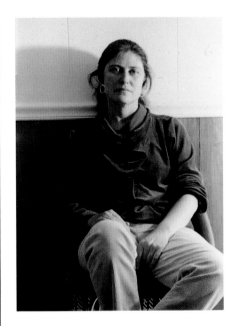

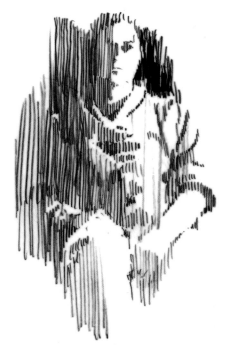

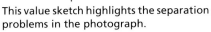

This value sketch highlights the separation problems in the photograph.

A corrected value sketch.

1. Separation Problem

One of the advantages of painting from photographs is that you can see potential problems and work out solutions before you paint. At first glance, this photo of Linda presents no problems. Yet if you take a second look you can see that her dark blouse forms a barrier separating her hands and arms from her face. This is even more obvious when you make a value sketch, such as the one on the left.

2. Correcting the Values

This time the photograph itself suggests a solution; notice how the left side of Linda's body (our right side) is bathed in light while the shadow side of her dark blouse almost disappears into the background. If we raise the value and lighten the intensity of the color on the left side of her blouse (our right side) we can diminish the value contrasts near her arm, as shown in the value sketch on the right. I pull the blouse color into the background and just suggest the outline of her body so she appears to be emerging from the picture area. With the addition of the arbitrary dark values behind her head, attention is drawn to her face, where it belongs. The problem of separation isn't limited to photographs of people. Anytime there are strong competing parts in a photograph it's up to you to make the changes necessary to arrive at a unified composition.

Reposition Elements to Fill Excess Space

Too light.

Too dark.

1. Dealing With Poor Exposures

Don't give up if a photo you want to paint is either too light or too dark to make out any detail. Take the negative back to your photo finisher and ask for a better print. That's what I did with this photograph of an Egyptian fruit salesman. The face is clear on the original print but shadow shapes on his clothing are almost completely washed out. The darker print brings out the shadows on the clothing but facial detail is barely visible. Between both prints there's enough information to paint this photograph.

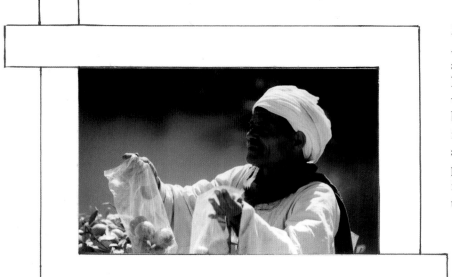

2. Filling Excess Space

A more important problem is the amount of space above the model's head. Think of space as having weight; any shape placed too near the bottom of the picture area diminishes in importance because the space above it seems to push it out of the picture area. In this case, the solution is simply to place the figure nearer the top of the page.

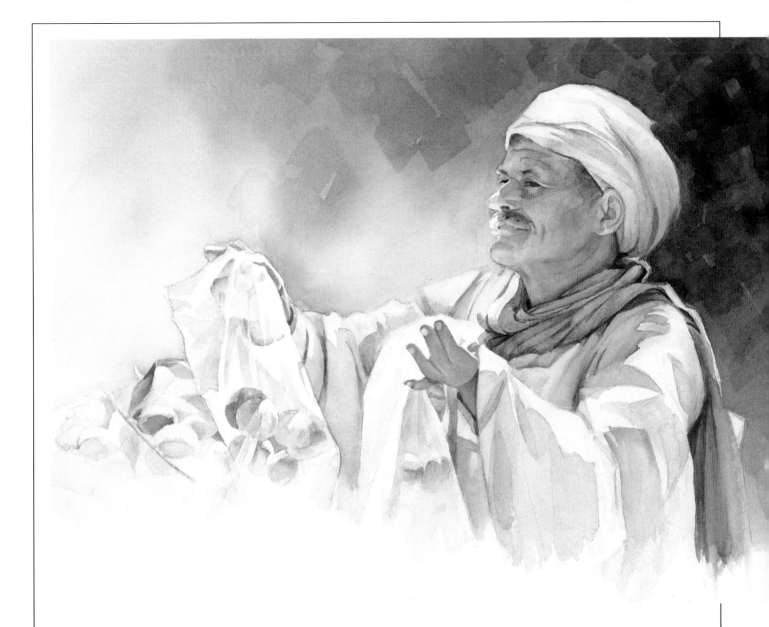

Points to Remember

1 Even if it has problems, a photo that interests you makes a great subject. Problem photos force you to think and allow you to work out solutions before you paint.

2 Use mini-mats to block out problem areas and suggest the boundaries of your composition.

3 Value sketches help you identify problems and plan patterns of lights and darks. By putting tracing paper over your initial outline drawing, you can make a value sketch without having to redraw the subject.

4 Many problems with photos can be corrected in your painting by moving, omitting or substituting elements. Don't paint everything just because it's there.

5 When substituting or adding new elements to your compositions, make sure they are the proper scale and perspective.

6 Think of objects as shapes, not things; then be selective and limit the number of shapes in your painting.

7 Your composition should only have one dominant shape or group of shapes. Make sure background shapes don't compete with the main form.

8 Empty space has visual importance, or weight, and must be regarded as part of the composition.

5
Answers to Students' Most-Asked Questions

This section is kind of a potpourri of subjects based on the questions students have asked during my years as a teacher. As always, I'll do my best to tell you what has worked for me, but I certainly don't have all the answers. Keep experimenting and questioning as you learn. There are many solutions for every problem you will encounter.

I chased this feisty rooster for some time before I was able to snap this picture. To turn this photo into a painting, it was necessary to create a new background that would enhance the importance of the rooster and show off his flashy feathers.

Barnyard Boss, 20" × 17" (50.8cm × 43.2cm)

"What About the Background?"

Probably the question I have been asked most often is, "OK, now what do I do with the background?" To answer that question, understand that a background is to a painting what an accompanist is to a soloist. Its purpose is to enhance and enrich the total performance. The background area should help tell the story and help set the mood of the painting. Harmonious shapes should reinforce the dominant theme, and contrasting ones should be added for interest. The goal is to create a composition where the dominant theme emerges from the background shapes. The best time to plan the background is when you make your value sketch.

You've probably heard all that before, and in the words of one of my students, ". . . Sure, but what will I do with the background?"

On the following pages are four tried-and-true methods for developing backgrounds early in the painting process, which will force you to make background decisions as you go. Bob Wood said you should always leave room in your planning for inspiration—here is your opportunity to give it a try. I think you'll find it a fun way to paint.

Painting the Foreground Colors Into the Background

1. Studying the Photo
The first step is to study the photo and look for places in the foreground where the values are near the same as those in the background. If you squint your eyes you can see that the shadow shapes on some of the petals blend into the background. They seem to disappear because they are the same value. These are the places where we will begin painting.

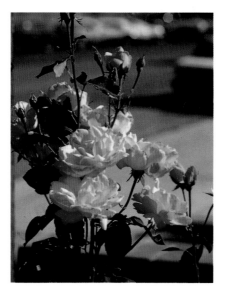

2. Pulling Shadow-Shape Colors Into the Background
Trace the drawing onto watercolor paper. When we begin, paint the shadow shapes one at a time, then pull the color into the background, enclosing the lighter petals next to the shadow shapes we just painted. Repeat this process as many times as you can.

I used Rose Madder Genuine with touches of Permanent Rose for this shadow shape, and in addition to pulling this color into the background, I also pulled it down into the flowers beneath. As I pulled the paint into the background I softened the edges so they might disappear with the next layer of paint. As you work around the picture area you will establish several *lost edges*—places with no border between the foreground and background. Lost edges help make your subjects appear to emerge from the background rather than looking as if they were pasted on top.

Without even knowing it, you've

now committed yourself to painting the background at the same time as the foreground! You're forced to consider the entire picture area as you progress, rather than leaving it to haunt you. Another advantage of this method is you are less likely to introduce unrelated colors into your painting.

3. Continuing to Pull Color Into the Background

I continued to work around the painting in this manner, finding color to pull into the background, then painting the detail after the color had dried. The dark leaves and petals on the left side of the picture provided a convenient place to stop—the dark colors we'll add there will obscure any ragged edges.

4. Painting the Stems and Leaves

The dark stems and leaves on the right side of the picture were painted right over the background color. Up to now, the painting has been monochromatic—using only shades of red—but now that I've added these green leaves, I need to repeat these colors somewhere else in the painting. First I added Cobalt Blue to the Rose Madder Genuine and painted around the top roses. I like to paint only as far as I can conveniently control the paint. In this case I could use the vertical stem near the center of the picture to hide any transition from one side of the picture to the other.

5. Adding Blues, Greens and Violets

The final step was to dampen the area above the roses and use a soft brush to add cool blues, greens and violets. I began with a mixture of Winsor Blue and Permanent Rose near the roses on the left, then added more blue and a touch of Winsor Green as I approached the top of the painting. Next I dampened the bottom of the painting and flooded in Winsor Green, Winsor Blue and Raw Umber. After everything was dry I suggested a few background leaves with darker values of the same color.

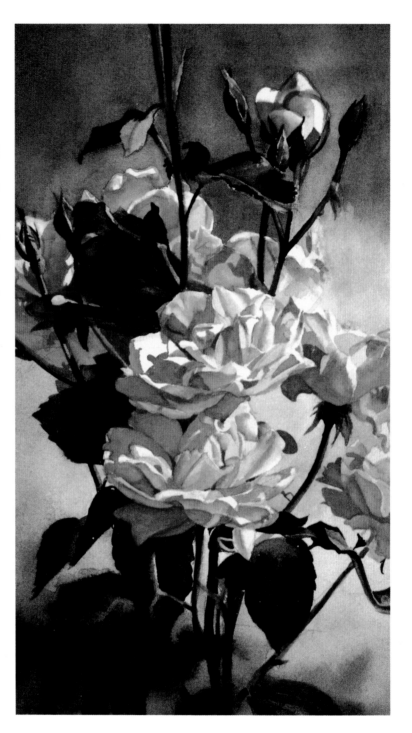

Painting the Background Colors Into the Foreground

1. Studying the Photo

The model in this photograph is a local radio personality with a beautiful voice who was nice enough to pose for me. I know this isn't a very good photograph, but by squinting your eyes and using a little imagination, you can see areas of equal value. As in the last demonstration, we have the obvious advantages of lost edges and harmonious colors, only this time we will pull and soften background colors into the foreground.

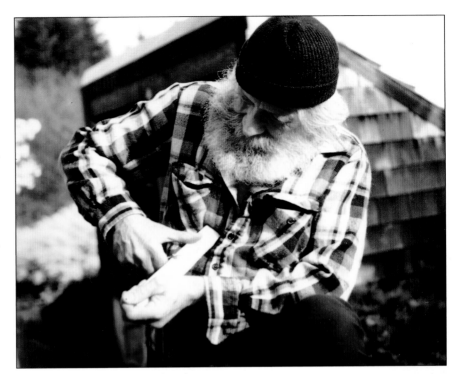

2. Painting the Face

I began by painting the model's face. In this close-up you can see the skin color in shadow is a mixture of Permanent Alizarin Crimson and Burnt Sienna, and the reflected light on his cheek is Cerulean Blue with Viridian Green. I added a mixture of Permanent Alizarin Crimson and Cobalt Blue to paint the cool shadows under his eyes.

The beard is Cerulean Blue, Burnt Sienna, Raw Sienna and Rose Madder Genuine, added one at a time onto a damp surface.

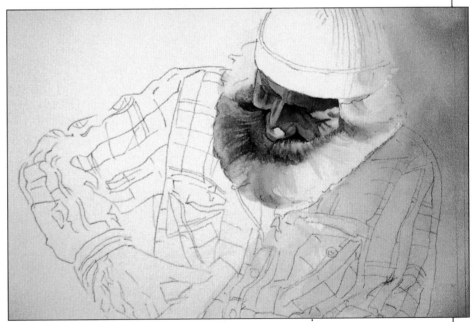

3. Adding the First Background Wash

After everything was dry, I re-wet the paper around the beard about two inches (5.1cm) into the background. Then, starting in the top right corner, I used a warm gray mixture made by combining Burnt Sienna, Cobalt Blue and Rose Madder Genuine to paint down to about an inch (2.5cm) from his beard and into the body of the shirt. This color will become the light part of the plaid, as well as softly frame the edges of his beard.

4. Painting the Background Into the Shirt

I repeated step three, darkening the value of the background by adding more pigment to the mixture. I painted this warm gray background color into the stripe across his right (our left) shoulder and sleeve—this color becomes the middle-value stripe. Then I began to detail the rest of the stripes on his clothing using Permanent Alizarin Crimson, Winsor Blue and Burnt Umber for the darker warm gray squares; and some of the same colors as I used for the beard—Raw Sienna with touches of Burnt Sienna in the darker areas—for the yellow-orange stripes.

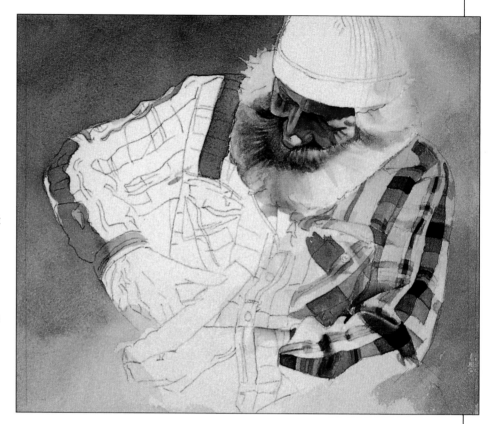

5. Adding the Background Color Into the Shadow Shapes

I added the shadow shapes to his shirt and open collar, and the background color into his shirt and sleeve.

6. Finishing the Painting

His cap was first underpainted with a light value of Winsor Blue, grayed with Burnt Sienna. When the paint had dried, I painted over the same area with the warm gray in his shirt to soften the blue and add detail. The final step was to paint the model's knee and the background around his hands with the same dark gray used to paint the dark squares in his shirt.

As you can see, I used the same background values and the same colors in the photograph, but by pulling the background colors into the foreground figure, the painting becomes a unit.

Painting the Background First

1. Planning the Composition

Here is a third way to help you lose the background blues. This time we'll paint the background first. This method works well when you paint landscapes, still lifes or floral subjects.

As you can see, I experimented with my mini-mat corners to find a more interesting composition. By adjusting the picture area, the white poinsettia petals become more dominant. Now carefully study the photograph, squinting your eyes and looking for the light and dark pattern across the picture. You aren't looking for exact edges, just a general idea of the flow of dark and light.

2. Adding the Underpainting

Once you have a general plan in mind, transfer the drawing to 300-lb. (640g/m²) watercolor paper, or a piece of 140-lb. (300g/m²) paper that has been stretched. Thoroughly wet the watercolor paper and use a brush loaded with pigment to darken all four corners of the picture area; this will help keep the white petals from leading the eye right out of the painting. Try to include both warm and cool colors in the underpainting—I used Cobalt Blue, Permanent Alizarin Crimson and Raw Sienna. Apply the colors one at at a time and let them blend on the paper. As you paint the dark shapes across the picture area, leave plenty of white paper. If you can't decide how much white to leave, just remember the story of the three bears: You'll need enough white space for Papa Bear, Mama Bear and Baby Bear.

After the underpainting has dried the value should be in the middle range. If it's too light it will disappear during the painting process, and if it's too dark it will obscure your subject. I try to keep the value between three and four on my value scale. In some places the soft underpainting will flood into the light areas and create a wet look not possible with any other medium. These soft edges, combined with the depth of color, will give structure and interest to your painting.

3. Painting the Petals

After the paper has dried, start anywhere you wish and paint as you normally do—the underpainting will serve as the color for the lighter passages as well as enhance the depth of color in the darker passages. As you can see in the close-up, the petals were painted with colors drawn from the underpainting. The white petal in the center of the right side appears to come forward when the underpainting is darkened on the petal behind it.

4. Painting the Backlit Petal

Notice the petal on the lower left of the photograph is backlit. We are looking at the shadow side of this petal, but because of its translucent quality, the light penetrating the petal casts a warm glow and silhouettes the shape of the petals behind it. This petal is cooler in color temperature than the ones in direct sunlight.

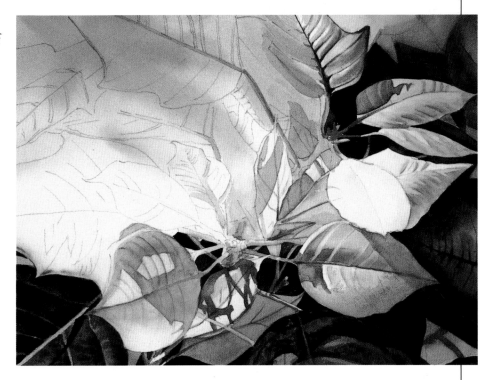

5. Finishing the Painting

I find it more interesting to paint the dark colors as I go. If you remember that horizontal surfaces are cooler than vertical ones, you will easily recognize that some of the leaves are yellow-green, while others are more toward blue. I painted around the veins in the leaves, letting the underpainting give them color. The veins in the petals were painted with a combination of Sap Green and New Gamboge. In a few places I used a crevice dark (Permanent Alizarin Crimson and Burnt Umber) to accent the very darkest area.

The initial underpainting may become almost obscured, but it has become a part of the overall color in the foreground as well as in the background, thus creating color unity in the painting.

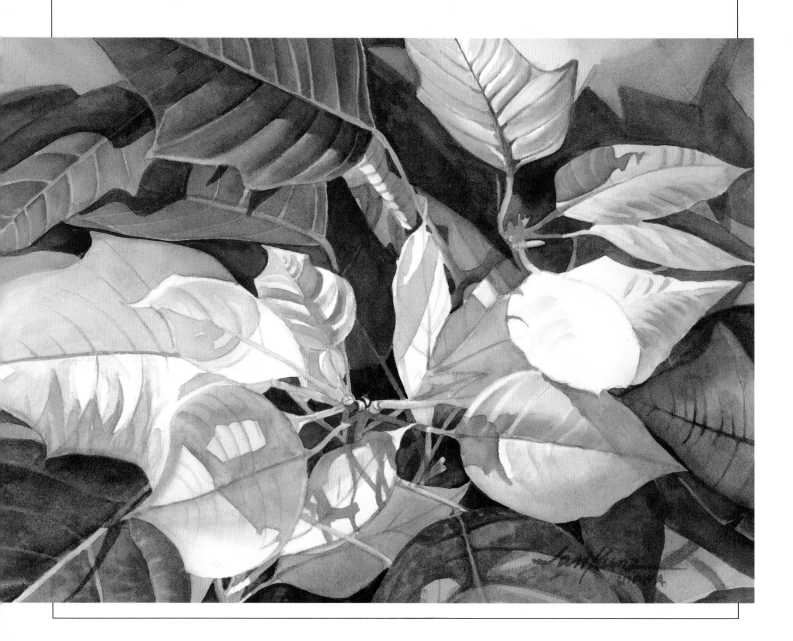

Painting the Background Last

1. Starting With a Completed Subject

For the purpose of this demonstration, I completed Greg's face and shoulders without giving any thought to the background. The paintings I see in class are usually at this stage of completion when I hear the first moan and inevitable question, "What about the background?" Before you tackle such a problem, it might be good to give yourself some time. Decisions made when you are tired or upset are often not the best ones. It might be better to wait another day.

Probably the worst time to think about adding a background is after

you have painted something you like and you fear adding a background may ruin your painting. First, ask yourself if you really need a background. If your answer is yes, put the painting aside and plan out the background on scrap paper. This will reduce your chances of adding a background that doesn't work with your painting.

2. Making Value Sketches

Now that I have painted myself into this pickle, I need to plan my painting in reverse. First go back to the original photo or sketch and do several black-and-white studies of possible backgrounds. When you're working from a photo, you can make several sketches quickly and get the values down on paper before you lose the inspiration: Just put a piece of mat acetate or tracing paper over the photo and use a soft pencil or marker to copy all of the dark shapes you've used in your painting. With these shapes as a basis for your composition, you can experiment with background shapes and values until you arrive at a pleasing pattern of darks and lights. Consider placing dark against light/light against dark and the direction you want the viewer's eye to travel. Remember, you're not obligated to put "things" in the background—abstract shapes will accomplish the same purpose.

Here you can see the sketches I made. The photo of Greg was taken in my studio. Usually you can find something in a photo to suggest a background, but when you encounter a photo like this one—where there are no interesting background shapes or colors from which to gain inspiration—the background will have to be of your own making. My first attempt was too busy, but the last try had possibilities.

3. Making Color Sketches

With the value studies as a guide, next make several color sketches to see how more color would affect those colors already in the painting. The shapes in my watercolor sketches differ somewhat from those in my value sketches because a brush behaves differently from a pencil, but the ideas are there.

When you decide to add the background to a painting last, remember you've already established your dominant form, so at the very least, the background must not detract from it. A solid color is nearly the same as no background at all, and it can be boring to your viewer. Simple shapes and related colors are often the answer.

I read somewhere you should never be satisfied with your first color sketch—if you intend to make only one, there's no real reason to make a color sketch at all. That proves to be good advice. In the first sketch I used blue in the background to repeat the color of Greg's shirt, then overlaid warm, red-violet shapes. The sketch I finally decided on turned out to be the exact opposite arrangement.

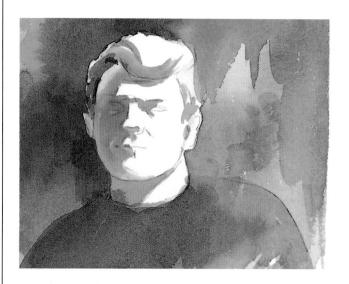

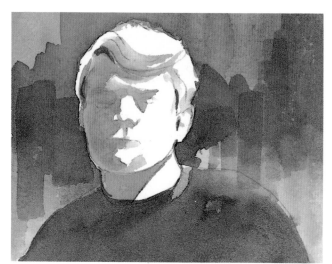

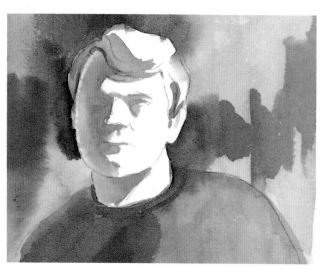

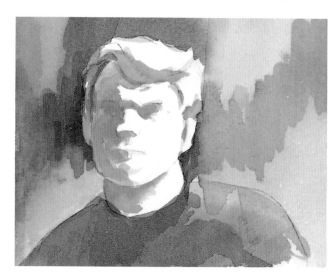

4. Adding the Background

Even though you have a careful plan in mind, it's tricky to add a background to a nearly completed painting. For a unified composition, try to bring some of the background color into the foreground you've already painted. As you can see, I let some of the background color flow over the shirt to soften the separation. When the background dried, I used a soft brush moistened with clear water to soften the boundaries of Greg's face and neck.

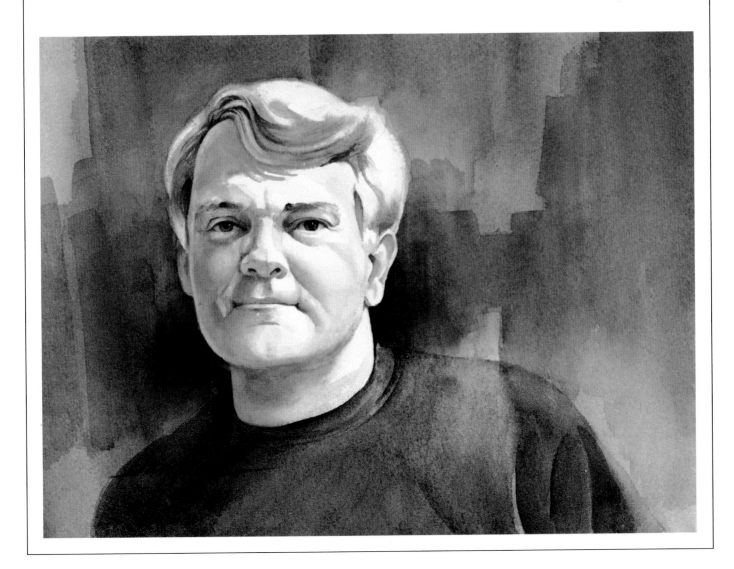

"How Do I Mix Brilliant Darks?"

A few years ago, several painting buddies and I formed a "tongue-in-cheek" organization called NWWA (No Wimpy Watercolors Association). As charter members, we vowed to do our best to stamp out pale and prissy painting. Our weapon is value, the most important aspect of color.

As I mentioned on page 18, to create the illusion of sunlight, we must make the shadow shapes 40 percent darker in value than sunlit areas. That means sometimes we have to combine colors to achieve a value dark enough to represent the shadow side of an object. Shadow shapes can be very dark, but it's important these colors remain brilliant. Colors like Burnt Umber, Payne's Gray, Brown Madder and Indigo are capable of achieving dark values, but they contain so much black they can appear flat and lifeless when used alone. It's important you know the properties of pigments so you can make informed choices.

"What If I'm Using a Color With a Short Value Range?"

When you're using colors with a long value range, it's not too difficult to get good dark values. It's a different story when confronted with colors like yellow and orange with a very short value range. The trick to clean darks is to mix these short-range colors with long-range colors on the same side of the color wheel. (The problem of muddy colors only arises if we combine equal parts of complementary pigments—those opposite each other on the wheel—in dark values.) The color wheel above may help you see this more clearly.

The greatest color challenge for mixing clean dark values is yellow. Try to avoid pure yellow in the background of any painting. Yellow-green or yellow-orange are, in my opinion, better choices because pure yellow has a way of coming forward to dominate the scene. Even in the foreground yellow can be difficult to handle. It's value range is short, so to represent the shadow side of a yellow object in sunlight, we add other colors.

This yellow rose is a good example. Yellow (such as New Gamboge) right out of the tube is very light, not much darker than the white paper. To achieve the illusion of sunlight, the shadow shapes must be four values darker than the sunlit side. The darkest values in my sketch were first painted with a mixture of Raw Sienna, Burnt Sienna and Permanent Rose. These colors are all from the same side of the color wheel and have longer value ranges than the yellow. I waited for the passages to dry, then glazed the whole shadow area with Cadmium Yellow to hold the color integrity.

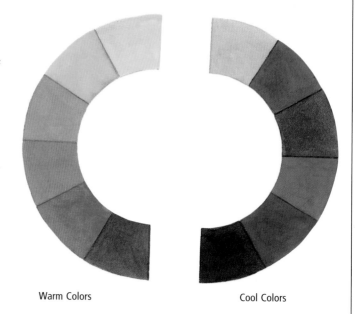

Warm Colors Cool Colors

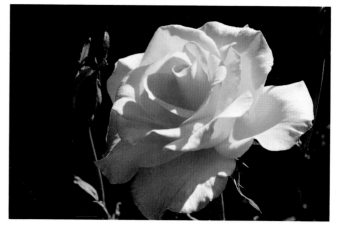

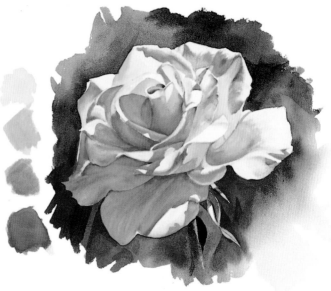

"What Colors Do I Use to Paint Black Skin?"

This is another question I have been asked many times. The easy answer is anything but black and Payne's Gray. Black skin is full of beautiful color, and not every complexion can be painted with the same colors. Black skin can pick up highlights and seem to change color and color temperature between the sunlit, shade and shadow sides. Whenever you paint a face, regardless of its color, break it down and ask yourself which cool colors can be seen around the eyes and forehead and which warm colors are on the cheeks.

In this example I used Cerulean Blue to suggest the light on the gentleman's neck and temple, and added Rose Madder Genuine to the blue as I approached the forehead. His cheeks are Burnt Sienna and Permanent Alizarin Crimson. The shadow on his forehead cast by his cap is Winsor Blue and Permanent Alizarin Crimson. Before the pigment dried, I added Sap Green along the edge of his cheek to suggest reflected light.

Permanent
Rose + Burnt Sienna

Permanent Alizarin Crimson + New
Gamboge + Burnt Sienna

Cerulean Blue + Rose Madder
Genuine + Burnt Sienna + Burnt Umber

Permanent
Rose + Winsor
Blue + Burnt Umber

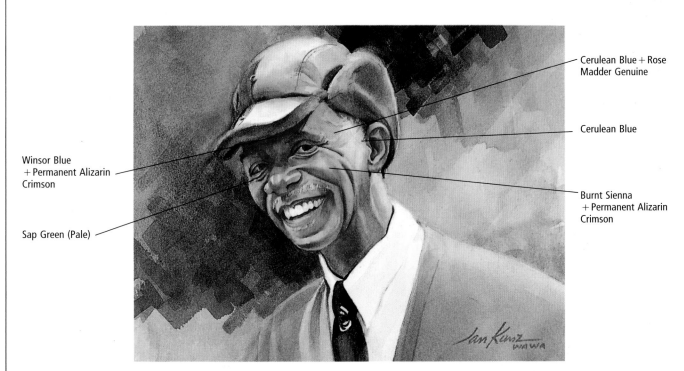

Cerulean Blue + Rose
Madder Genuine

Cerulean Blue

Winsor Blue
+ Permanent Alizarin
Crimson

Burnt Sienna
+ Permanent Alizarin
Crimson

Sap Green (Pale)

"How Do I Draw and Paint Eyes?"

Approximate Diameter of Eyeball

The eyeball is a sphere.

The upper and lower lids meet at nearly a right angle and don't extend beyond the eyeball.

The highest part of the upper lid is near the nose.

The tear duct is attached to the eyeball.

This line represents the inner part of the lid. The lowest part of the lower lid is closer to the side of the head than the nose.

Make allowance for the thickness of the lid sliding over the eyeball.

Show the visible edge of the lid.

Make allowance for the thickness of the lid sliding over the eyeball.

The dent under the eye corresponds to the bottom of the eyeball.

This is another frequently asked question. I think the best way to draw eyes is to *construct* them. Before we start, take a good look at your own eyes. Notice the eyeball is just that, a ball or sphere, and the lids that protect it have dimension. The top lid slides over the eyeball, while the bottom lid is nearly stationary. They meet almost at right angles at the outer edge (away from the nose) and do not extend beyond that point. The pink tear duct is not part of the eyeball.

1. Determing the Size of the Eyeball

To determine the size of the eyeball, measure the distance between the outer edge of the eye, where the upper and lower lid meet, and the inside corner. Don't include the tear duct. This measurement will become the diameter of the eyeball.

2. Constructing the Shapes

We begin by drawing the sphere of the eyeball, then locate the tear duct out to one side. Next draw a line to represent the inside part of the lid curving over the rounded surface. Notice that the highest part of the upper lid is near the nose, and the lowest part of the lower lid is near the side of the head. Draw another line just outside of the first one to allow for the thickness of the lid. If you have any questions, take another look at your own eye. The goal is to make the eyeball look round and fitted inside the eyelids.

The iris is a disk lying on the surface of the spherical eyeball. If you look at it straight on, it appears to be circular. It only appears elliptical if viewed from a steep angle. The pupil is located in the center of the iris, and in straight frontal views is equidistant from the edges.

When your drawing is complete, erase the construction lines and we're ready to paint.

3. Creating Dimension

If you stop and study them, eyeballs are not totally white. Even when they aren't bloodshot from painting too long, they still have color. For that reason I usually paint the skin color right over the eyes. When the color is dry, I put a drop of Cobalt Blue mixed with Burnt Sienna in each corner of both eyes, then pull the drops of color together with clear water so the corners are darker than the center. This will enhance the feeling of roundness.

4. Painting the Lids

Every time you darken a color, you are pushing it back. To make the lids appear to curve out over the eyes, paint along the fold over the eye using Permanent Alizarin Crimson mixed with a touch of Burnt Sienna, then immediately follow it with a passage of clear water to lighten the color between the lid and the brow. I painted the bottom lid in this same way. Notice I was careful to avoid the edges of both eyelids. I used a stroke of Cobalt Blue across the eyeball to suggest a cast shadow from the lid and to reinforce the feeling of roundness.

5. Painting the Brow and Pupil

I drew the eyebrow into position and painted its length with clear water. Then I dipped my brush into the well of Raw Umber and picked up a gob on my brush. By putting the brush down where I wanted the darkest color and then lifting it quickly, the color ran down the pre-moistened brow.

I finished modeling the lid, and added pink to the tear duct. The underside of the upper lid is in shadow so I painted it the usual 40 percent darker than the skin color.

I know you are wondering about the bright green pupil. I intend to paint the eye brown, but by underpainting it with green first, the secondary highlight will have more depth of color.

6. Finishing the Eye

I used Burnt Sienna to paint over the iris. Before the color dried, I squeezed the water out of my brush and picked up a spot of the brown pigment I had just applied so the underlying green would show through. It is this secondary highlight that suggests the translucent quality of the eye. The lashes were suggested with a stroke of the brush. Don't be tempted to paint every lash. Finally, I used my craft knife to pop out a brilliant highlight by burying the tip of my blade in the spot where I wanted the highlight to appear, then lifting up quickly at an angle, removing a small chip of paper.

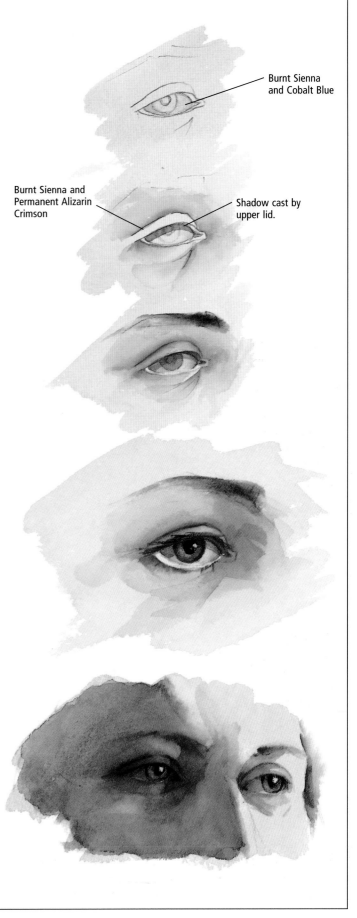

Burnt Sienna and Cobalt Blue

Burnt Sienna and Permanent Alizarin Crimson

Shadow cast by upper lid.

Can you see that I used this method to paint these eyes? When you paint an eye, or anything else for that matter, you should paint what you see. Often the eyes are in shadow and we see nothing but a dark place where the eye should be, or there is a deep shadow that obscures all but a small portion. However, before you can successfully paint part of an eye, it is necessary to understand its construction.

"How Do I Paint Teeth?"

Teeth have been known to cause a few problems even the dentist can't fix, so let's look at the steps it takes to paint this pretty woman's smile. As you can see, I drew her teeth and lips very carefully. You may never paint teeth in such detail again, but this kind of study may help you understand how to paint teeth the next time you encounter them.

1. Creating Dimension

Unless my subject is a person with exceptionally dark skin, I paint the flesh color right over the teeth. The lady in this photo has fair skin, so we'll paint a mixture of New Gamboge and Permanent Alizarin Crimson right across them. When the color is dry, put a dot of Cobalt Blue mixed with Burnt Sienna at the outside corners of the teeth, then wash out your brush and pull the two spots of color together with clear water. This is the same method we used to make the eyeballs appear rounded.

2. Adding Cast Shadows

If the teeth are in the path of a cast shadow, paint the shadow color right over them. Now and then you may see places where teeth appear rounded, as in this photograph, but don't be tempted to suggest these areas with dark lines between the teeth. Paint these places as you would any other curved surface.

3. Finishing the Teeth

Paint the gums with Permanent Alizarin Crimson warmed with a touch of Burnt Sienna. Define the bottom of the teeth with a very dark combination of Permanent Alizarin Crimson and Burnt Umber. This is a dark crevice, so keep this mixture toward red. Dampen the entire bottom lip

with clear water, and draw a brush loaded with Cadmium Red along the bottom edge. Let the color blend into the dampened area.

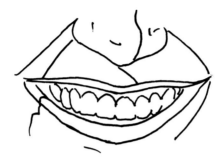

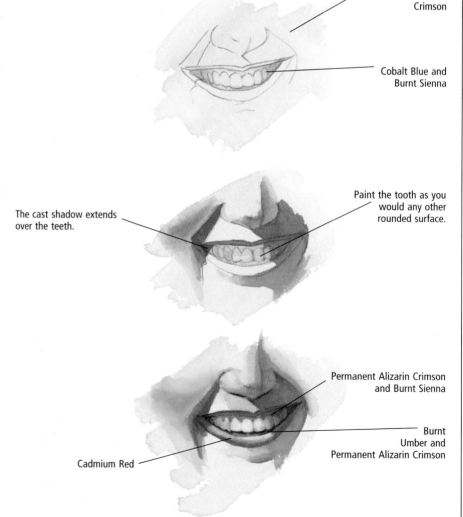

New Gamboge and Permanent Alizarin Crimson

Cobalt Blue and Burnt Sienna

The cast shadow extends over the teeth.

Paint the tooth as you would any other rounded surface.

Permanent Alizarin Crimson and Burnt Sienna

Burnt Umber and Permanent Alizarin Crimson

Cadmium Red

"How Do I Paint the Nose and Mouth?"

Five pieces of cartilage make up the tip of the nose.

The nostrils point toward the tip of the nose.

The upper lip can be divided into three sections, the lower lip into two.

Drawing and painting a nose is fairly simple if you remember a nose is shaped like a long, narrow wedge, joined at the forehead with another small wedge. The bone in the upper part of the nose influences the general shape. The lower part is formed of cartilage and is more or less elastic. It continues to grow and change with age. In the left drawing, I've exaggerated the size of the five pieces of cartilage that form the tip of the nose. In the right illustration viewed from underneath, the nostrils point to the tip.

To draw the mouth it may help to think of the upper lip as having three parts and the lower lip only two.

Not only is it important to construct each feature properly, but it must relate to the rest of the features. In these watercolor sketches you can see the relationship between the nose and the mouth.

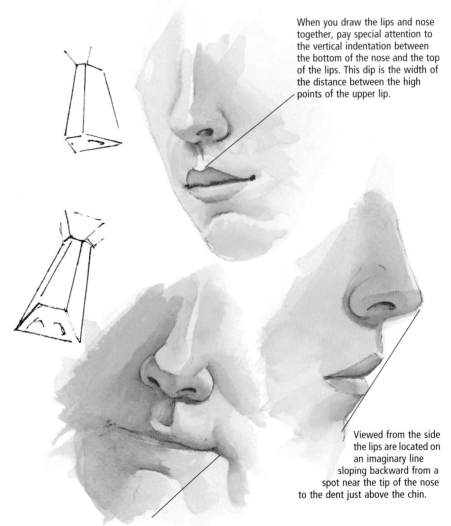

When you draw the lips and nose together, pay special attention to the vertical indentation between the bottom of the nose and the top of the lips. This dip is the width of the distance between the high points of the upper lip.

Viewed from the side the lips are located on an imaginary line sloping backward from a spot near the tip of the nose to the dent just above the chin.

Notice that where the corners of the mouth run into the cheek there is a depression or hollow. This hollow is especially visible in men.

"How Do I Paint Ears?"

I've noticed many students are somewhat careless when it comes to painting the ear. Correct placement is most important. In a side view, the ear is on a line halfway between the front and the back of the head, and is at an angle more or less parallel to the nose. Looking from the front, you can see that most ears slant down and in, parallel to the sides of the head. The top of the ear is on a line with the eyebrow, and the bottom is on a line with the base of the nose.

Often the ear is partly obscured, but it's important to understand its general construction. Think of the ear as a disk divided into three sections with the "bowl" in the center. This bowl is surrounded by curves and whorls that are different in each person; however, the general construction is the same.

Painting portraits is great fun, and in my opinion much easier than painting flowers. Many of us avoid painting portraits because they seem intimidating. Frankly, I can't think of anything more intimidating than a collection of multicolored petals, each with a different shape than the one next to it. Yet so many painters overcome these obstacles to paint wonderful florals. I hope at least some of you will add the new dimension of portraits to your subjects.

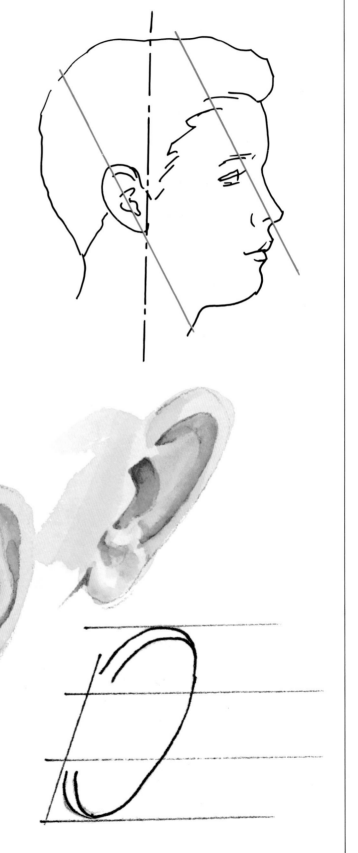

"How Do I Paint Folds?"

Folds are an important part of many paintings, and they deserve serious attention. Even if it is your intention to only suggest clothing or drapery, the part you show should be accurate. To show you more clearly some of the individual characteristics of the basic folds, I took a kitchen chair and a piece of cloth out onto the deck and re-created them for you.

Lying in a cupboard, a piece of cloth doesn't have much form or character, but in use, it takes on a life of its own. When you smooth a napkin out on your lap, the cloth takes on the shape of your supporting legs. Drop it, and it will lie on the floor in an inert pile; pick it up by a corner and it will hang in folds, pulled downward by the force of gravity. Hold it by two corners and the character of the folds change. Change your hold again, and the cloth assumes still a different shape. This is true because the laws of gravity and the principle of the points of support (where you are holding it) are at work.

Another principle, just as important to the understanding of folds, is the principle of the point of tension. The shape of the fold will change when it is subjected to tension, depending on how the fabric is pulled or twisted. If you are wearing long sleeves, bending your arms will demonstrate how tension influences a fold: The folds will appear to be radiating from your elbow.

While it's clear all folds are governed by gravity and the points of support and tension, they are also controlled, to a great extent, by the shape of the object underneath.

There are only seven basic folds, but you will see many modifications caused by slackness, fullness, tension and direction.

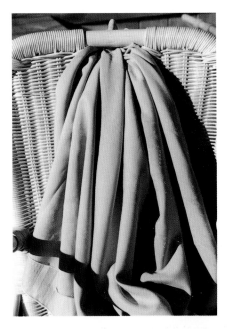

Diaper Fold
A diaper fold is triangular and drops away in a curve from one point to another. When you draw this fold it's important to accent the sweep of the curve. The top of the curve is usually sharp, but it falls away into soft folds.

Pipe Fold
Pipe folds occur when a large amount of cloth is gathered into a small area, such as a skirt gathered about the waist. The waist is the point of support and the folds gradually fan out and radiate downward. Most drapes hang in pipe folds. Pipe folds should be drawn to convey a cylindrical feeling.

Inert Fold
Some artists call this a "dead" fold because it's not active, it just lies limp on an inactive surface. Its overall feeling must be characteristic of the surface upon which it is resting. The inert fold is usually composed of a variety of bunched-up, irregular forms.

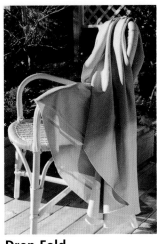

In this photograph I taped the edge of the cloth to the leg of the chair to create tension, which changed the character of the drop fold. Tension will alter the character of any fold and must be considered when painting drapery.

Drop Fold
The drop fold (left) creates many types of folds as it falls. It can have any number of twists and turns, and sometimes it will even hang straight like a pipe fold. The important characteristic is that it's dropping, regardless of the zigzags, turns and twists.

Half-Lock Fold

You can probably see a good example of a half-lock fold in your own clothing. If you are seated, look where your legs and torso meet. You will also find these folds in back of your knees. A half-lock fold occurs when a tubular or flat cloth changes direction.

Spiral Fold

The final fold to consider is the spiral fold. It is usually formed when a tubular piece of cloth is wrapped around a tubular form. If you've ever had your pajamas twisted about you, you have experienced a spiral fold at work. Whenever you wring out a rag or twist a piece of cloth you are creating a spiral fold. To draw this fold it must appear to revolve around a form. It's easy to tell the difference between a zigzag and a spiral fold. The zigzag does not radiate about a tubular surface or appear to be twisted.

Remember the drapery itself has a form made up of flat or curving planes. The forms will vary depending on the way the drapery is hung. By learning to recognize the basic folds, you may find it easier to use drapery convincingly. A carelessly drawn drape can destroy any conviction your work might otherwise have.

Painting Folds

The folds in this painting describe the pull and crush of the clothing, adding to the warmth of the embrace. If the folds in your composition are properly drawn, painting them is easier if you think of them as shapes. Ask yourself the same questions you would ask if you were painting any other

Zigzag Folds

The zigzag fold usually occurs when a pipe fold is bent. The zigzag is on the slack side of the bend. At the moment I'm wearing an oversized sweatshirt. If I stretch out my arm I can see a series of zigzag folds running down my sleeve. The zigzag folds in the photograph are considerably softer than those along my arm. The difference is in the texture of the fabric.

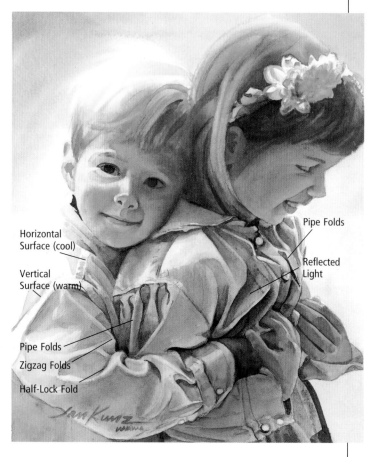

Horizontal Surface (cool)

Vertical Surface (warm)

Pipe Folds

Zigzag Folds

Half-Lock Fold

Pipe Folds

Reflected Light

object: Which part of this shape is facing the light? Where is the reflected light? Where are the cast shadows? Folds can add rhythm and interest to your work, so take time to study the folds and paint them carefully.

"How Do I Calculate Scale and Perspective?"

Whenever you intend to combine the elements from more than one photograph to make a painting, you are immediately faced with the problem of scale. Every object must look like it belongs in the new composition; nothing can be too big or too small. If you know the relative size of two objects and they are placed close together, it's not difficult to draw them in proper relationship to one another. Many times all you'll need is common sense to make the right decisions.

Another consideration is the matter of eye level. You would not use an overhead view of an automobile and combine it with a photograph of a man taken at ground level. Obviously the photographs we choose to combine must be at nearly the same eye level. It's much easier to make the right decisions if you have at least a rudimentary understanding of perspective. If you are unsure of yourself, take the time to read this section. Several artists I know think "perspective" is a dirty word, but the only thing difficult about perspective is its reputation.

The rules of perspective are based on the simple observation that objects appear smaller the further away they are from your eyes, and likewise, the distance between them becomes smaller. You also become aware that objects diminish in an obvious direction toward a definite height or level. While we think of this level as the horizon, the fact is that the true horizon is always the level of your own eyes. Perhaps part of the confusion comes from the fact that the terms *horizon line* and *eye level* are used interchangeably. Whichever term is used, it boils down to the fact that

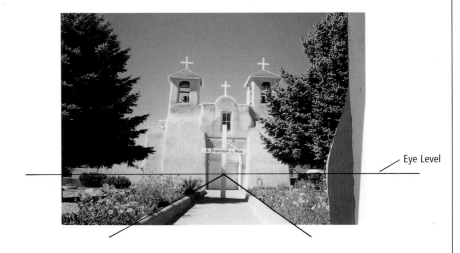

Eye Level

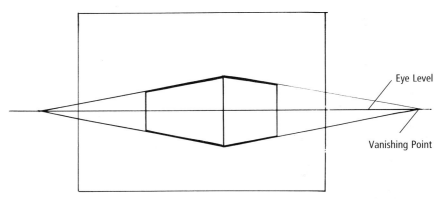

Eye Level

Vanishing Point

objects get smaller the further they are away, and they seem to vanish at a point somewhere on your own eye level. When you take a photograph, the eye level (or horizon line) is at the level of your camera. It follows then that eye level (or camera level) on a photograph can be found by locating the place at which objects seem to vanish. The lines forming the sides of the path in the photograph above converge at a point marking the camera level or eye level.

Finding the Eye Level

Let's suppose you're looking at the corner of a box. You will see that all parallel lines on the front of the box

seem to come together as they go back in space. The parallel lines on the side of the box also seem to come together, but in another direction. Both of these vanishing points are on the horizon or eye level. A drawing made from this viewpoint is called a *two-point perspective* drawing. All parallel lines converge at one vanishing point somewhere along a line representing your eye level. I'm going to say that again because that is really the key. All parallel lines vanish to the same point somewhere along your eye level. These same principles hold true whether you are drawing the Capitol building, the inside of a room, a piece of furniture or the boards in the floor.

This marine service building is shaped very much like the box on the previous page. To find the vanishing points on the left side of the building, I extended the line of the roof and the line along the bottom of the building until they converged at point A. On the front of the building, I extended an imaginary line extending between the eaves, and another along the bottom of the building until they converged at point B. If you extend the lines at the top and the bottom of the sign, they would also converge at point B.

A

Eye Level

B

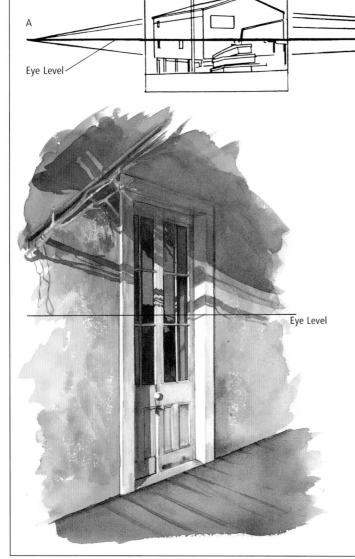

Eye Level

Shortcut Method of Estimating Eye Level

A quick way to determine eye level in a photograph is to find a place where a vertical and horizontal member are at right angles to one another. This is because your eye level is just that—level. You can often estimate the eye level. For instance, in this sketch of a doorway, the top of the center windowpane is tilted slightly down to the right. The bottom of this same pane is tilted slightly up. Therefore the eye level must be somewhere in the middle.

When you combine two or more photographs, every pictorial element in your drawing must vanish to the same horizon line. I promised to explain how I determined the height of the child in the demonstration starting on page 70. I first extended the parallel lines of the siding on the house to find the vanishing points, then, by connecting these points, I established the eye level.

The next step was to determine the height of the front door. Most inside doorways are six feet eight inches (203cm), but since this in an exterior door, I estimated it to be seven feet (213cm) high. A three-and-one-half-foot-tall (107cm) child standing immediately next to the door would reach about halfway to the top. To determine his height at a location on the path, I drew a line from the horizon line through the base of the door and out until it reached a spot in front of the bottom step. Next I repeated the process only this time I drew the line from the same point on the horizon line through the three-and-one-half-foot (107cm) level to establish the location of the top of the boy's head.

In this demonstration the child in the photo is below our eye level. His new position on the path is likewise below our eye level. When you decide to combine photographs be sure the eye level in both photographs is nearly the same.

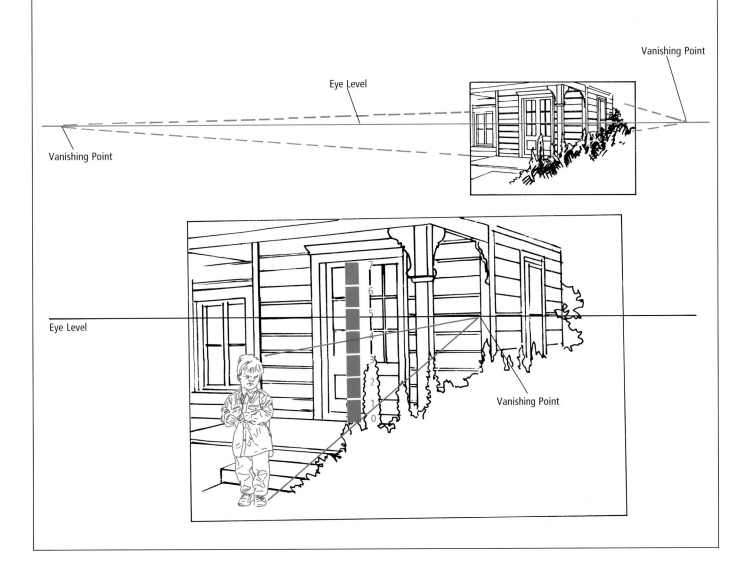

Easy Perspective Tricks

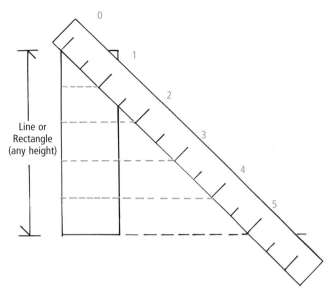

Quick-Size Scale

Sometimes you may need to know the approximate height or width of an object.

When you work with photographs there is usually no convenient scale to give you that information. However, if you know the approximate size of any object in the photo you can make your own scale easily and quickly.

For instance, in the demonstration on page 70 I wanted to divide the height of the door into seven equal spaces representing one foot each. In the example above, let's suppose we want to divide this line (or a rectangle) into five equal parts. (You may find the explanation easier to understand if you look at the example first.) Extend the baseline until a 5-inch (12.7cm) ruler reaches diagonally between the top of the line (or rectangle) to be divided and the baseline. Mark off the divisions along the side of the ruler, and extend them back, parallel to the baseline, to the space to be divided. This method works no matter the number of divisions to be made or the size of the space to be divided.

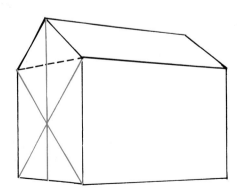

Determining Tilt

Most of the time it's relatively easy to determine the eye level in a photograph, but it's more difficult if you are painting outdoors. Many students have difficulty seeing whether a line or plane is going up or downhill. If you know someone who has that trouble, here is a tool you can make that will solve the problem. Cut two strips of cardboard about twelve inches (30.5cm) long and an inch (2.5cm) wide and use a paper fastener to attach them at one end. To use the tool, line one strip up with the vertical member of the object you're looking at and the other along the tilted edge. The direction of the tilt will immediately become obvious.

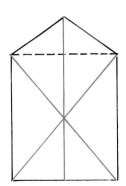

Finding the Center of a Rectangle

This is a simple tip, but it's one I used almost every day when my job was to paint portraits of houses. You probably remember from high school math that to find the center of a rectangle, simply draw lines connecting the opposite corners. That method works when you draw the end of a building and want to find the center of a gabled roof. It also works if you're drawing that building in perspective.

"Why Didn't I Make the Show?"

People often ask which paintings are most likely to be accepted into a show. Here are a few suggestions:

1. Show Your Best Work Your entry should always represent your best work. Don't try to second-guess what the judge might like to see. A great painting is a great painting no matter what the subject.

2. Size If you must select between two paintings of equal merit, I suggest you choose the larger. The fact is, big paintings are easily noticed and can make an immediate impression on a judge. When paintings are juried from slides, size is not as much a factor.

3. Presentation The way you present your painting can make or break your chances at making a show. A mat should always be clean and carefully cut with no glitches at the corners. Beware of colored mats—they can become more important than the painting. Light mats with dark in-liners and dark frames can be distracting. Such a combination can give the appearance of a road running around the outer edge of the painting. The mat and frame together should enhance the beauty of the work. Obviously, the corners of a frame should be tight, and the wire carefully attached with no exposed ends that might cause injury. Avoid sawtooth hangers.

When you have met all the rules and presented your work in a professional manner, relax and know you have done everything you can do. Making a show or getting an award is a signal of growth, and the experience can inspire you to even better work. However, it is possible to do well in one show and not be accepted for the next, so don't be discouraged. Shows seldom represent the opinion of more than one judge, and you may not agree with him. I have several friends who have never been accepted into a show, and some who have never felt the need to enter one, but they still make their living by creating wonderful paintings. The joy of painting is in getting there. There are always new things to try. As soon as an artist thinks he is wonderful, he has stopped growing and, in my opinion, he becomes a bore.

What You Should Know About Judges and Shows

A judge is faced with constraints not immediately apparent to most artists. An obvious limiting factor is available space. The judge is almost always asked to limit his selections to a certain number, so it's possible that some very nice paintings will be left out. He is also obliged to put together a diverse show that will hold the attention of viewers with a wide variety of interests. For that reason

Points to Remember

1 When it's time to tackle a problem painting, don't start work until you can face your painting with confidence. If that isn't possible, at least give yourself a good night's sleep before you begin.

2 Don't leave the background to haunt you! Make several value plans and color sketches in order to have a good idea of what your background will be *before* you start to paint. If you're stuck on the background, take another careful look at your photograph to find interesting shapes that may inspire you.

3 Make a unified composition by connecting foreground and background shapes and colors. Lost edges help make your subject appear to emerge from the background rather than looking cut out and pasted on.

4 Folds are governed by (1) the laws of gravity, (2) points of support and tension and (3) the shape underneath. Break them into basic shapes and draw them accurately.

5 Horizontal surfaces are cooler than vertical ones.

6 To achieve brilliant dark values when using colors with short value ranges, like yellow and orange, mix them with colors with longer value ranges from the same side of the color wheel.

7 Black skin, like all skin colors, is made up of many colors, both warm and cool. The only colors you won't see in black skin are black and Payne's Gray.

8 Objects appear smaller the further away they are from your eyes, and likewise, the distance between them becomes smaller. Objects diminish at the true horizon line, which is always your eye level. All parallel lines vanish to the same point somewhere along your eye level.

he will look for a variety of subjects and the best in both representational and abstract art. What is more, he is often permitted little time to make his selections.

Whether your painting makes the show or not, you should know why your work was included, or why it was not! Given the opportunity, most judges are happy to discuss their decisions.

Photos to Get You Started

In this section you will find photographs for you to paint. I have painted from almost all of these photographs at one time or another, so I can give you an idea of what to expect.

Kelly

Before you paint Kelly, study the photograph to see the yellow reflected light on her chin and at the base of her nose. There is cool reflected light under her eyebrows and along the shadow side of her temple. Look for the differences in color temperature in her hair. It is noticeably cooler where her head is turned from the light than it is on the vertical surface facing the sun.

Yellow Roses

If you decide to paint all three roses in this photo, rearrange them into a better composition, as I have done in my painting on pages 126 and 127. A fast way to do this is to outline their shapes onto a piece of tracing paper, cut them apart and move the pieces around until you decide on their new positions. The shadow shapes on the petals are a full 40 percent darker than the sunlit areas, so you might want to refer to page 108 to see how to arrive at these dark values.

Morning Glory

Here is a great opportunity to use what you know about color temperature, even though the differences appear subtle in this photograph. Take a careful look at the shadow cast by the stamen. Notice the color looks cool where the shadow meets the sunlit surface, but seems to get warmer as it approaches the center of the flower.

Cole

This good-looking youngster is fun to paint. There is lots of color in this face, so go for it! Notice the cool colors at his temple and forehead are in marked contrast to his warm cheeks and chin. The shadow cast across his nose and beneath his eyes has hard edges, but the edges across his cheek are very soft.

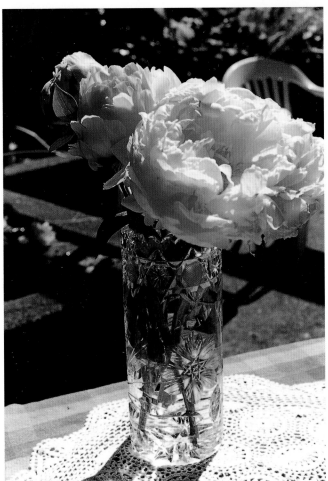

Teddy Bears

Try putting your hand over the vertical posts in this photo and notice how much more important the bears become. As painters, we must omit any pictorial element that diminishes our center of interest. Even though it's not very apparent, don't forget to look for reflected light on the shadow side of the bears.

Peonies in Crystal

If you're a beginner, don't be turned off by this subject. The shapes in the vase can be painted one at a time, and combine to create the illusion of crystal. Even the peonies can be painted shape by shape. I suggest you make a careful drawing.

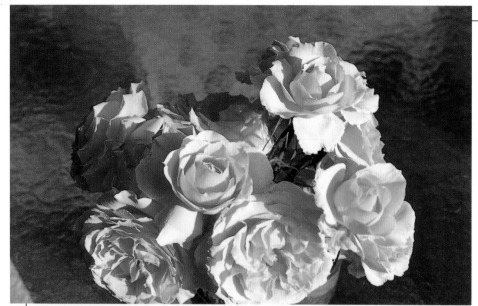

Bouquet of Roses

The challenge here is to create your own composition. You may want to limit your painting to one section of the photograph, or maybe you'll want to paint several roses from different areas. If you rearrange the flowers, be sure the light is coming from the same direction. If you turn one rose too far, you may have to rethink the shadow shapes. Try to lead your viewer's eye across the page and create one dominant shape.

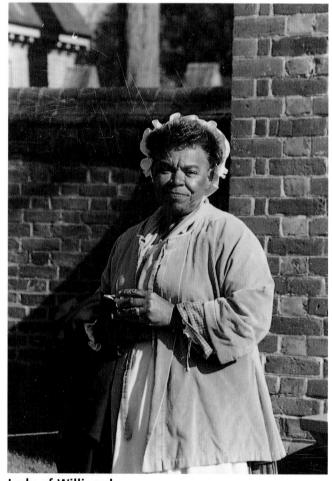

Rooster

It is the beauty of the rooster's feathers that make him an interesting subject. Look at the reflected light bouncing off his neck and tail feathers. There are Winsor Green and Winsor Blue reflections, not to mention Brown Madder and many other colors in his feathers. I suggest you make a careful drawing, then paint the shadow shapes first before adding any detail. Making a careful painting of this subject will take time, but I think you'll find it rewarding.

Lady of Williamsburg

There are great shadow shapes across the face and figure of this hostess I photographed in Williamsburg, Virginia. Can you see the blue reflected light on her cheek and along the side of her arm? Here is your opportunity to find ways to bring the background into the foreground and create a unified composition.

Roses in Crystal

Consider using your mini-mats to find the best placement for this vase of flowers in the picture area. Once you have decided on the format, make a few preliminary sketches to decide on value distribution and color.

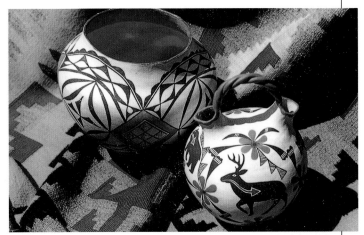

Indian Pots

Here is a problem photo for you to solve. This uncomfortable composition is created by the strong lines leading to diagonally opposite corners of the photograph. Your challenge is to re-arrange the blanket so your eye remains within the picture area and the pots become the focus of your painting.

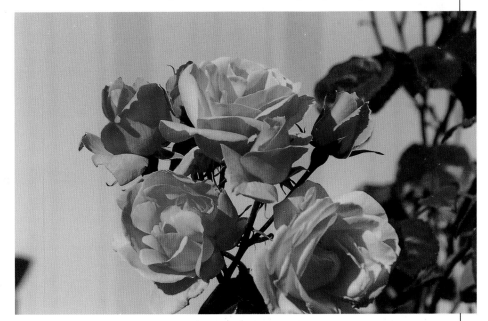

Garden Roses

This photo has great possibilities. Try using mini-mats to find a new composition, or use just a few of the roses and rearrange them. The background in this photo is flat, so I suggest you make a value plan to help you arrange both positive and negative shapes.

Conclusion

If all we get from our artistic endeavors is an appreciation of the world around us, we are well rewarded. A friend once told me he saw a beautiful golden tree with light streaming through its branches. In excitement, he pointed and said, "Look! Look!" His companion looked and replied, "What? What?" Our reward is that we know "what" and so much more.

The demonstrations in this book are meant to be straightforward, simple solutions to common problems. They don't pretend to be works of art; they are here to get you started. By knowing what works, you have the basis to experiment with new solutions. You'll have disappointments, but the joy of painting is in the search for personal satisfaction.

There are art associations filled with talented, dedicated people who are eager to share their enthusiasm for watercolor. Many associations welcome anyone interested in painting. In addition, there are many fine books to guide you twenty-four hours a day. Remember, in the final analysis, you are your own best teacher.

Jan Kunz

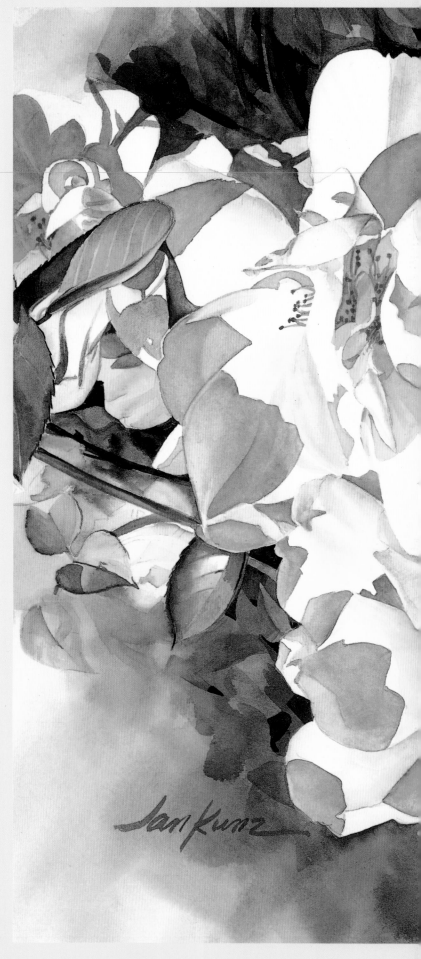

Three Yellow Roses, 22" × 15" (55.9cm × 38.1cm)